JESSIE FIORITTO

NEVERTHELESS, SHE WAS CHOSEN

Inspiring Devotions and Prayers for a Woman's Heart

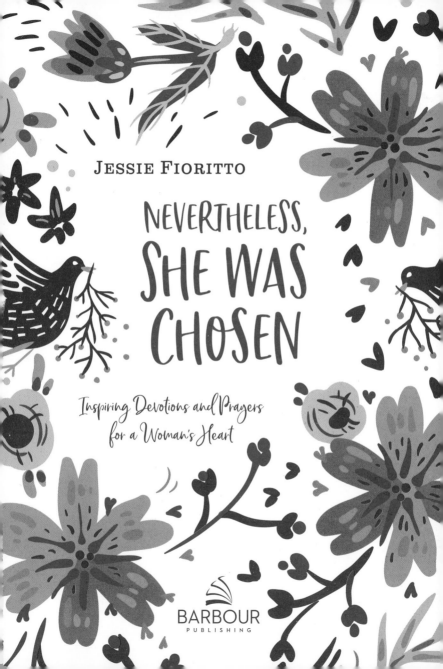

BARBOUR
PUBLISHING

Published by Barbour Publishing, Inc., 1810 Barbour Drive, Uhrichsville, Ohio 44683, www.barbourbooks.com

Our mission is to inspire the world with the life-changing message of the Bible.

Printed in China.

NEVERTHELESS, YOU ARE CHOSEN

You are the ones chosen by God, chosen for the high calling of priestly work, chosen to be a holy people, God's instruments to do his work and speak out for him, to tell others of the night-and-day difference he made for you—from nothing to something, from rejected to accepted.

1 PETER 2:9–10 MSG

The world is watching. You, beloved daughter of a loving God, have been chosen for a high calling. You've been chosen for holiness—to live out your life as an expression of God's love for all the world to see. Now that God has changed your life, you've been handpicked to walk away from sin and live a lifestyle that stands out. He wants you because He loves you deeply, and He longs for your company every day. You've been chosen for so much more than a fleeting, self-indulgent existence. You were made for eternity with the One who counts even the hairs on your head. You belong to God! Now what will you do?

CHOSEN

God has chosen you. You are
holy and loved by Him.
COLOSSIANS 3:12 NLV

Sister, we've all felt unwanted, left out, or overlooked at some point in our lives. We've all experienced the painful burn that scorches our face when we believe we're insignificant or irrelevant in the seemingly happy crowd of popular people. But don't believe this insidious lie of the enemy—you're never unwanted. Beloved, you have been chosen. You are wanted by the great God of this universe. Not only are you wanted, but you are loved ecstatically by Him—no strings attached. When you feel insignificant, lonely, or depressed, remember that your Father loves you. He picked you especially, because He sees the unique way He designed you.

. .

Heavenly Father, protect my mind from dangerous lies.
Help me always to trust that Your love for me is
without bounds. In Jesus' precious name, amen.

LIVE LIKE HE LOVES YOU

You are holy and loved by Him. Because of this, your new life should be full of loving-pity. You should be kind to others and have no pride. Be gentle and be willing to wait for others. Try to understand other people.
COLOSSIANS 3:12–13 NLV

Jesus died to make us holy. He lived our righteousness because we couldn't, and then He suffered an excruciating death to cover our filth and allow us to walk into eternity unhindered. He rescued us from the jaws of eternal death and gave us abundant life in its place. And because of this great love story for the ages, we should be changed. The knowledge of what He did for us should pierce our sin-shrouded hearts. Try to understand the struggles of others today and gently lift them up through love.

. .

Father, I know You love me. Help me to live out Your love toward others. Amen.

CHOSEN TO FORGIVE

Forgive each other.
COLOSSIANS 3:13 NLV

Three little words. And yet living by their creed can be as formidable as summiting Everest. Someone hurts our feelings, and we grab on to that offense with the tenacity of an emaciated junkyard dog, gnawing his last bone. We refuse to let it go. We refuse to forgive. Instead, we play their painful words on a loop in our imagination, breaking open the wound over and over. Somewhere in our pain we forget that we too have been forgiven—probably of much greater offenses. Loved one, your Father in heaven chose you as His prized possession. He forgave you. And He asks you to do the same. Is there someone you need to forgive today?

. .

Father, soften my heart of stone. Help me get
control of my thoughts and choose to forgive those
who have hurt me. In Jesus' name, amen.

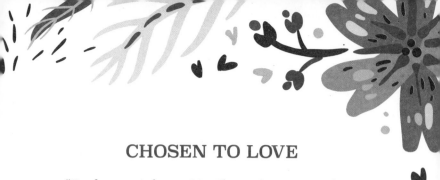

CHOSEN TO LOVE

"You have not chosen Me, I have chosen you. I have
set you apart for the work of bringing in fruit....
This is what I tell you to do: Love each other."
JOHN 15:16–17 NLV

God wants us to make no mistake about the Initiator of our relationship with Him. He chose us, not the other way around. He picked you for His kingdom, and He didn't just single you out of a crowd: He created you specifically with love and great detail and set you apart for the work He has prepared for you—the work of showing Jesus to others. No one can finish the tasks He has planned for your life quite like you can, because you were made for them. His instructions are simple: love. Go out and show someone Christ's love today.

· ·

Lord, show me the work of love You
have earmarked for me today. Amen.

YOU BELONG TO HIM

"If the world hates you, you know it hated Me before it hated you. If you belonged to the world, the world would love you as its own. You do not belong to the world. I have chosen you out of the world and the world hates you."

JOHN 15:18–19 NLV

Be careful about fitting in too well with the world's culture. If you're embraced by a godless society and blend like a chameleon into its masses, it should be a warning sign to you. Jesus said that the world would reject His followers with the same animosity it showed Him. But don't be discouraged! You belong to Him. He has chosen you right out of this world and into a better one—the eternal kingdom of His Father.

. .

Father God, it hurts when the world hates me because I love You, but this trial has a silver lining—it proves that I belong to You. Amen.

BECAUSE YOU BELONG TO HIM. . .

*"If they made it very hard for Me, they will make
it very hard for you also. If they obeyed My teachings,
they will obey your teachings also. They will do all
these things to you because you belong to Me.
They do not know My Father Who sent Me."*

JOHN 15:20–21 NLV

Through the tough times, when you're being trampled by a world that has rejected Jesus, remember that you won't receive better treatment in this fallen place than Jesus did. But there is hope! Jesus warned us of the difficulties so we wouldn't be easily discouraged by the severe hardship we might experience in this world. But your hope rests in *who* you belong to. Don't be swayed by popular culture's mocking voice. Heaven awaits!

* *

*Father, someday when I'm with You in eternity, I know
the trials of this world will seem like an insignificant blink.
Give me strength to endure. In Jesus' name, amen.*

HELP FOR HIS CHOSEN

"The Helper (Holy Spirit) will tell
about Me when He comes. I will send Him
to you from the Father. He is the Spirit of
Truth and comes from the Father."
JOHN 15:26–27 NLV

When your courage wanes, remember the Helper. You don't have to do life all alone; you have help. The Holy Spirit moved into your heart the moment you believed in Jesus' death and resurrection. Don't waste this resource! The Holy Spirit can teach, strengthen, and equip you with everything you need. And you're His witness in this world to spread the amazing news. Has Jesus changed you, given you hope, assisted you in struggles, or helped you to solve problems? Tell someone.

. .

God, thank You for sending the Holy Spirit to help me. Teach
me to rely on You, and show me who I can tell today about
what You've done in my life. In Jesus' name, amen.

CHOSEN TO BEAR FRUIT

*"I am the true Vine. My Father is the One Who
cares for the Vine. He takes away any branch in Me
that does not give fruit. Any branch that gives fruit,
He cuts it back so it will give more fruit."*
JOHN 15:1–2 NLV

An untended fruit tree is a gnarled mess of branches and small, blemished fruit. But pruning will encourage both growth and fruit production. Jesus says that we are like this fruit tree. And our loving heavenly Father is the One wielding the clippers. At times His gentle rebukes for sinful behavior and correction for wrong attitudes can pinch. But He knows that a pruned tree will give more fruit. His love will flow more freely from you when you are shaped by His hand.

. .

*Father, even when Your pruning feels difficult or painful,
I want to yield to Your ways. Make me more fruitful. Amen.*

MADE FOR HIS PURPOSE

"Before I formed you in the womb I knew you,
before you were born I set you apart; I appointed
you as a prophet to the nations."
JEREMIAH 1:5 NIV

Your life is neither cosmic coincidence or an accident of nature. Quite the opposite in fact. The Creator of the universe knew you before you were born. He has been planning your life for generations. He carefully crafted your personality and talents, He chose your ancestors and the timing of your birth. Even when it feels as if your existence is insignificant, know that your life has meaning and purpose in God's kingdom. Your heavenly Father sees you and knows every graceful arc and rough edge of your personality—and He loves you. Ask Him today what you should do.

. .

Father, thank You for knitting me together with such
careful detail. Show me Your will for my life. Amen.

CHOSEN DAUGHTER

"The father said to his servants, 'Quick! Bring the best robe and put it on him. Put a ring on his finger and sandals on his feet. Bring the fattened calf and kill it. Let's have a feast and celebrate. For this son of mine was dead and is alive again; he was lost and is found.'"

LUKE 15:22–24 NIV

Maybe you've collapsed on rock bottom. No matter whether we've stubbornly gone our own way or circumstances beyond our control have mercilessly cornered us, the enemy works to convince us that we must become "good enough" for God. But in truth, beloved, He has already chosen you. The returning son was shocked by His father's embrace when he'd planned to beg for a slave's position. But through Jesus no slaves reside in His household, only heirs! Precious daughter, He celebrates you with open arms.

Father, I'm grateful and humbled that I can come home. Amen.

13

CLING TO HIM

*"You shall follow the LORD your God and fear Him;
and you shall keep His commandments, listen to
His voice, serve Him, and cling to Him."*

DEUTERONOMY 13:4 NASB

In a "take charge of your destiny" world, trusting God can be a hard sell. It's vital to keep our perspective in check. When we're shopping online for a new pair of boots, we read every review to discover their performance in all types of weather. And God doesn't ask us to trust Him blindly without evidence either. The Bible is loaded with positive reviews from faithful people who chose to follow His leading, even when things weren't looking so good. Allow God to lead, even in your mess, and listen for His voice. Never let go of the One who sees both ends of eternity.

. .

*Father, teach me to trust You more.
In Jesus' name, amen.*

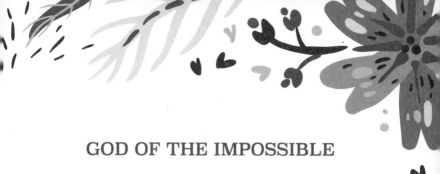

GOD OF THE IMPOSSIBLE

"Nothing will be impossible with God."
Luke 1:37 NASB

Sometimes life works itself into a tangled knot. We can't see the way forward, and much like the Israelites trapped on the shores of the Red Sea, we're tempted to despair. But God has a history of making ways through impassable problems. Keep your faith alive! God can and will show up in your desperate circumstances if you wait for Him. After all, He has big plans for you. Put your mustard seed–sized faith in the God of the ages, and He'll move the mountains standing in the way of His plans.

. .

Lord, when I don't see a way to mend a friendship, overcome a devastating loss, or accomplish an out-of-reach goal, help me to trust in You. You created the world from nothing and raised the dead to life, so my problems are not too much for You. Amen.

HE LISTENS

"Then you will call upon Me and come
and pray to Me, and I will listen to you."
JEREMIAH 29:12 NLV

This verse holds an amazing promise: the God of heaven and earth, the ruler of all kingdoms and powers, listens to me. If you've ever stood outside on a clear night under a glittering canopy of stars and felt insignificant, this verse assures us that we are anything but invisible to God. Just pray, and He will listen. And not only will He listen, but He'll help, comfort, and teach. He isn't merely a powerless, empathetic listening ear. He is the One who spoke life into existence. When you speak He listens, and when He speaks things change. Take your cares to Him today.

Lord, I feel small in this universe, but You see me even in
the midst of the masses. You love me, and You can change
my circumstances. Thank You. In Jesus' name, amen.

NO TURNING BACK

We are not of those people who turn back and are lost.
Instead, we have faith to be saved from the punishment
of sin. Now faith is being sure we will get what we
hope for. It is being sure of what we cannot see.
HEBREWS 10:39–11:1 NLV

Keep your eye on the prize—it's good advice in competition and in Christianity. Our prize as followers of Christ may not be a higher-paying job, popularity, or the perfect life, but it's priceless nonetheless. Jesus chose us from the beginning of time to be the recipients of grace. He paid dearly to deliver us from a grave situation—the punishment of sin. Our faith assures us that our hope isn't misguided, that Jesus did indeed rise from the dead and deliver grace and eternal life to us.

. .

Lord, I never want to turn back from following You.
My faith tells me my hope in You is well placed. Amen.

WALK BY FAITH

Our life is lived by faith. We do not
live by what we see in front of us.
2 Corinthians 5:7 nlv

I like to plan, make lists, and do things in order. It makes me uncomfortable when I don't know what's going to happen next. Imagining the faith of Abraham leaves me in awe. God told Abraham to leave his father's house and go to a land that He would show Him. Now, maybe some of us wouldn't mind leaving a few pesky relatives behind, but Abraham had no idea where he was going! And he didn't ask God for an itinerary. Instead, he packed up everything he owned and set off for a promised inheritance.

* *

Father, sometimes I have no idea where we're going,
but I want to trust like Abraham and keep taking
the next step. Keep my eyes fixed on You so I'm not
distracted by what I see in front of me. Amen.

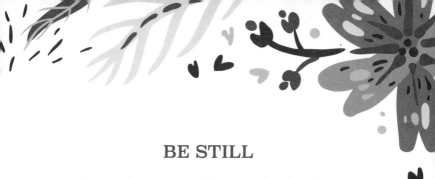

BE STILL

*Surrender your anxiety. Be still and realize
that I am God. I am God above all the nations,
and I am exalted throughout the whole earth.*

PSALM 46:10 TPT

Sometimes we need reminded that "God's got this." We wring
our hands and suffer panic attacks from the uncertainty of
living in this world, but all that anxious pacing is wasted energy.
Our time is better spent in prayer than in panic. God gently
shushes us like a mother to her upset child: *"Rest easy. Just be
still while I hold you. I'll take care of everything."* As children
we trust our parents completely to provide what we need and
keep us safe, but as adults it's easier to strive than to trust.
Today, rest in the knowledge that our God has big shoulders.

• •

*God, I give you my anxiety. I trust
You to work out Your plans. Amen.*

NEVER STOP BELIEVING

He never stopped believing God's promise, for he was
made strong in his faith to father a child. And because
he was mighty in faith and convinced that God had
all the power needed to fulfill his promises, Abraham
glorified God! So now you can see why Abraham's faith
was credited to his account as righteousness before God.

ROMANS 4:20–22 TPT

The Bible is filled with God's promises to us, His chosen children. The pages are lined with everything from our eternal home in heaven to everyday rest and peace in trusting Him. The key is to be like Abraham—never stop believing that God can and will do what He says. Abraham was fully convinced that although he and Sarah were physically beyond childbearing years, God would do the impossible and give them a son. And He did.

Father, I believe! I believe that You will
make good on Your promises. Amen.

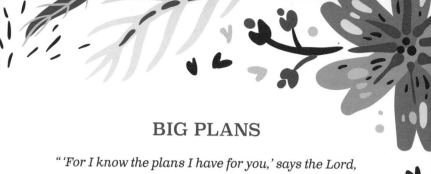

BIG PLANS

" 'For I know the plans I have for you,' says the Lord,
'plans for well-being and not for trouble,
to give you a future and a hope.' "
JEREMIAH 29:11 NLV

Abraham thought God was trustworthy, and his belief was credited to his heavenly account as righteousness. God had epic plans for Abraham's offspring—saving the world kind of epic. And He hasn't neglected you, His chosen daughter, in His planning. Comparison is an easy trap to stumble into. We look around and wish we could be like someone else. From the outside their life, family, or personality seem like a better option. But remember that if you're busy trying to be someone else, you're missing out on God's unique plans that only you can live.

• •

Father, I trust that You have something special
in store for my life, things You've positioned
me to do. Keep my focus on You. Amen.

LEAN IN

*Trust in the LORD with all your heart and lean
not on your own understanding; in all your ways
submit to him, and he will make your paths straight.*

PROVERBS 3:5–6 NIV

Every time we board an airplane, stow our carry-on, and buckle into our seat, we trust that even if we don't understand the physics involved, the plane has been correctly designed to defy gravity and fly us to our destination. We trust the engineers who do understand all that complicated math. And yet too often we fail to trust in God's abilities. Today, when you find yourself unsure about what to do, lean into God. Ask Him what He wants you to do, and then do it. He promises to straighten out those winding paths if only you'll trust Him.

*Father, teach me to trust You with my
whole heart and to be obedient. Amen.*

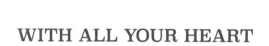

WITH ALL YOUR HEART

"You will look for Me and find Me,
when you look for Me with all your heart."
JEREMIAH 29:13 NLV

These words were penned to the surviving exiles in Babylon, people who probably felt abandoned by God after years in captivity. Sometimes we too lead ourselves into years of captivity to sin. We knowingly choose to do the wrong thing—gossip, addictions, lies, unforgiveness, and anger, and then we do it again and again. We walk right into the cell and slap the irons around our own wrists. And through our stubborn rebellion, God begins to feel distant. But there's hope for you, sweet friend. Just as He brought the Babylonian exiles home, He'll bring you home too. You'll find Him again if you search with your whole heart.

* *

Father, I've been wrong. Please forgive me.
Show me the way back to You. Amen.

THE END OF MYSELF

*Just then a woman who had been sick with a flow of blood
for twelve years came from behind. She touched the bottom
of His coat. She said to herself, "If I only touch the bottom
of His coat, I will be healed." Then Jesus turned around.
He saw her and said, "Daughter, take hope! Your faith
has healed you." At once the woman was healed.*

MATTHEW 9:20–22 NLV

As every option was exhausted for this woman, hopelessness
probably took root. But then she heard about Jesus. And she
believed He was the long-awaited Messiah, the Son of God, who
had the power to change what she could not, so she reached
out for the hem of His garment. And Jesus knew, as He always
does. When you reach the end of yourself, reach out to Him.

*Father, I know You have the power to change hard
circumstances. Help me turn to You first. Amen.*

SAFE HOUSE

GOD's a safe-house for the battered, a sanctuary
during bad times. The moment you arrive,
you relax; you're never sorry you knocked.
PSALM 9:9–10 MSG

Have you ever gone through bad times? Maybe you're feeling battered by life right now—as if you were chosen only to struggle and never to thrive. Friend, whether it's an illness, a wayward child, financial struggles, or anxiety, you can find hope, help, and shelter in your heavenly Father. As the scripture says, the moment you arrive in His presence, you'll relax. He may not remove all your problems, but He'll change and strengthen you through them. Go to Him in prayer. Find Him in His Word. Trust Him, and He will never forsake you.

. .

Father, I need a place of shelter, a safe
place to rest my anxiety-burdened mind.
I'm chosen to thrive in this dry place. Amen.

CURE YOUR WORRY

*Don't be pulled in different directions or worried about a
thing. Be saturated in prayer throughout each day, offering
your faith-filled requests before God with overflowing
gratitude. Tell him every detail of your life, then God's
wonderful peace that transcends human understanding,
will guard your heart and mind through Jesus Christ.*
PHILIPPIANS 4:6-7 TPT

A moment's peace is priceless, but what if that moment stretched
to a lifetime? Philippians maps out God's perfect plan for
everlasting peace of mind. In short, don't worry. Saturate your
day with prayer instead. Pour out your worries, frustrations,
fears, even your anger to the God who will always listen. He can
handle all your jumbled feelings—after all, He created emotions.
And have faith that God is in control. Thank Him for His tender
care. Then an indescribable peace will flow into your life.

*Father, thank You so much for replacing
my worry with peace when I trust You. Amen.*

HE BRINGS OUT YOUR BEST

God helping you: Take your everyday, ordinary life—
your sleeping, eating, going-to-work, and walking-around
life—and place it before God as an offering. Embracing
what God does for you is the best thing you can do for him.
Don't become so well-adjusted to your culture that you fit
into it without even thinking. Instead, fix your attention on
God. You'll be changed from the inside out. Readily recognize
what he wants from you, and quickly respond to it. Unlike
the culture around you, always dragging you down to its
level of immaturity, God brings the best out of you,
develops well-formed maturity in you.
ROMANS 12:1–2 MSG

You were chosen to stand out from the crowd. Just like the shocked little New Testament boy, God can feed five thousand with your two fish, be they time, money, skills, or even just a meal for your neighbor.

. .

God, bring out the best potential You see in me. Amen.

MY BEST THOUGHT

*But I gave up those things that were
so important to me for Christ.*
PHILIPPIANS 3:7 NLV

*Be Thou my Vision, O Lord of my heart;
Naught be all else to me, save that Thou art—
Thou my best thought, by day or by night,
Waking or sleeping, Thy presence my light.*

I love the lilting Irish melody of this hymn, "Be Thou My Vision." Its words are sometimes attributed to St. Dallàn, a sixth-century blind monk, yet he remained faithful that God was his vision, his best thought, and his only remaining light. All the world's treasures can't compete with the friend we have in Jesus. Is He the Lord of your heart today? Is He your best thought always, the light in your darkness?

. .

*Father, keep things in perspective for me when, as Satan
tempted Jesus in the desert, the things of this earth start
to look appealing. I give them up for You. Amen.*

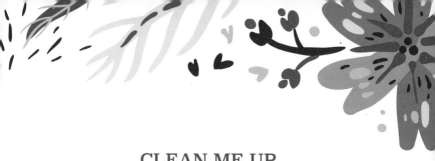

CLEAN ME UP

Create in me a clean heart, God, and renew a steadfast spirit within me. Do not cast me away from Your presence, and do not take Your Holy Spirit from me. Restore to me the joy of Your salvation, and sustain me with a willing spirit.
PSALM 51:10–12 NASB

The Bible says David was a man after God's own heart, chosen by Him to slay giants and reign over a nation as king. Chosen, just as you are, for God's purpose. But David wasn't perfect, and neither are we. This psalm gives hope to all who've ever messed up. David wrote this psalm from a place of desolate brokenness. He begged God not to cast him aside because of his sin, to restore his joy and willingness to do what's right.

* *

Father, I've sinned against You. But I know that if I confess, You are faithful to forgive. Bring back my joy. Amen.

WAIT FOR IT

But those who wait for Yahweh's grace will experience
divine strength. They will rise up on soaring wings
and fly like eagles, run their race without growing weary,
and walk through life without giving up.

ISAIAH 40:31 TPT

God has chosen you as His daughter to run *your* race. Sometimes
our packed schedules can make us feel important, and we
derive our sense of worth from our busyness instead of from
our identity as a child of God. But if we have no white space on
our page, not only can we begin to feel wrung out, but there's
also very little room for God to write His story on our lives.
Leave some margin in your time, wait for God's direction, and
He promises the hope of endurance.

Father, You haven't called me to do everything,
but You have called me to do something. Teach
me to wait so You can make me soar. Amen.

HOPE FOR THE HARD DAYS

*"If only my words were written! If only they were written
down in a book! If only they were cut forever into the rock
with an iron cutter and lead! But as for me, I know that
the One Who bought me and made me free from sin lives,
and that He will stand upon the earth in the end. Even
after my skin is destroyed, yet in my flesh I will see God."*

JOB 19:23–26 NLV

When you're slogging through a tough time, remember Job.
We've all had bad days, but probably not like Job's. God gave
Satan permission to test Job, and the enemy set out to crush
him. Job lost everything—possessions, children, health—but
Satan couldn't touch his most precious possession, his faith
in God. Job knew that no matter what atrocities happen in this
life, our Redeemer lives, and one day we will see God.

*Father, give me unwavering faith and hope like
Job that looks ahead to the day I'll see You. Amen.*

CHOSEN TO BE UNITED

*"May they all be as one, Father, as You are in Me
and I am in You. May they belong to Us. Then
the world will believe that You sent Me."*

JOHN 17:21 NLV

Getting along can be hard. Sometimes our feelings get hurt
or we're busy and don't want to be bothered by the burdens of
others. But Jesus' prayer for all believers was that they would
belong to Him and to one another, united as one force. This
unity is one of our strongest witnesses to a dark world where
it's everyone for himself. They see believers come together
with supernatural unity and know that something otherworldly
is happening. They begin to believe that Jesus is the Son of the
Most High.

. .

*Father, help me to get along with my faith family,
to overlook offenses, and to take the time to understand the
problems and setbacks others are struggling under. Amen.*

WISE INVESTMENT

*So be very careful how you live, not being like those with
no understanding, but live honorably with true wisdom,
for we are living in evil times. Take full advantage of
every day as you spend your life for his purposes.*
EPHESIANS 5:15–16 TPT

As I read these verses, the last phrase grabbed me: "Spend your life for his purposes." God has given us a set allowance of time here in this place. What will we purchase with the currency of our time? Paul urges the believers to spend it wisely for God's purposes. How are you planning to spend your time today? Are you wasting it on self-focused comfort or investing it in building eternal equity in the kingdom of God?

. .

*Lord, I'm living in dark days of rampant sin.
Give me wisdom to spend my life for You. Amen.*

ALL I EVER WANTED

He fulfills the desires of those who fear him;
he hears their cry and saves them.
PSALM 145:19 NIV

Have you asked God for things and He hasn't delivered? You may think that He isn't listening, doesn't care, or just can't help you. But maybe it's something else altogether. Maybe the things you're asking for aren't good for your soul, or perhaps you need to take a hard look at your motives for asking. Are they selfish? The more we get to know God the more His desires become our desires. And when what you want lines up with what God wants, you'll hear *"Yes!"* a lot more from your heavenly Father.

. .

Lord, change my heart, soften it, and remove the hard
core of selfishness that often has me thinking of my
own comfort and pleasure. Help me see the needs
of others. Help me see their need for You. Amen.

TRUST HIM

*Some trust in chariots and some in horses, but we trust
in the name of the LORD our God. They are brought to
their knees and fall, but we rise up and stand firm.*

PSALM 20:7–8 NIV

Do you hoard leftover pieces and parts because you might have
a use for them one day? Our safety nets give us comfort.
Whether it's money in the bank, food in the pantry, or life
insurance, we have some peace of mind knowing it's there—
just in case. Being prepared is never a bad idea, but scripture
also warns us to be careful about placing our trust in things
that will eventually fail. God is the backup plan who will never
fail us. Only He can help us stand firm when life collapses. In
what are you trusting?

* *

*Father, sometimes I look to my own resources
and resourcefulness to save me when I should
be trusting You. Help me trust You more. Amen.*

WHEN WORDS FAIL

The Holy Spirit takes hold of us in our human
frailty to empower us in our weakness. For example,
at times we don't even know how to pray, or know the
best things to ask for. But the Holy Spirit rises up within
us to super-intercede on our behalf, pleading to God
with emotional sighs too deep for words.

ROMANS 8:26 TPT

This verse is a warm hug to the troubled heart. Sometimes life is confusing and hard circumstances push us around. We don't know what to do or even what to ask God for. But it's okay, because the Holy Spirit knows exactly what to say, and He passionately prays for us. He is our greatest prayer warrior.

. .

Lord, it soothes my anxiety to know that You so
completely care for me in my human weakness.
Even when I'm too confused and helpless to pray,
You fill the gap with prayers on my behalf. Amen.

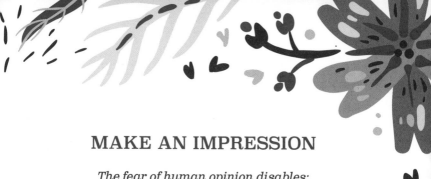

MAKE AN IMPRESSION

The fear of human opinion disables;
trusting in GOD protects you from that.
PROVERBS 29:25 MSG

Have you ever been paralyzed by worry about what others think? The enemy loves peer pressure. He tricks us into using the wrong standard because we fear judgment and crave acceptance. *But what if we thought as hard about what God thinks about what we're doing as we do about what friends and even perfect strangers think about how we live?* When we trust that what God asks of us is always ultimately in our best interest, He protects us from fearing that others won't like us because we follow Jesus.

. .

Father, keep my focus on the future—the bright
and glorious eternal life I have to look forward
to with You. Make my unwavering trust in You
a witness to all who see my life. Amen.

SAFE SPACE

My being safe and my honor rest with God.
My safe place is in God, the rock of my strength.
Trust in Him at all times, O people. Pour out your
heart before Him. God is a safe place for us.
PSALM 62:7–8 NLV

The world can be pretty hostile. When we wake up and turn on the news to reports of violence, widespread disease, and economic instability, the urge to dive back into bed and yank up the covers might overtake us. Getting through the day is a hard-won battle when anxiety and uncertainty assault us at every turn. But in the midst of all this trouble, we have the Rock—a big, sturdy fortress we can run to for comfort. God is a safe place to be. Pour out your problems to Him today.

. .

God, protect me and give me
courage in this dark place. Amen.

SPRING OF DESIRE

God, the searcher of the heart, knows fully our longings,
yet he also understands the desires of the Spirit, because the
Holy Spirit passionately pleads before God for us, his holy
ones, in perfect harmony with God's plan and our destiny.

ROMANS 8:27 TPT

The burdens we carry through this life can leave us feeling isolated and misunderstood. But God sees our hearts. And He has given us help so we're not overcome. Ponder Matthew Henry's words: "The Spirit, as an enlightening Spirit, teaches us what to pray for; as a sanctifying Spirit, works and stirs up praying graces; as a comforting Spirit, silences our fears, and helps us over all discouragements. The Holy Spirit is the spring of all desires toward God, which are often more than words can utter."

Father, Your Spirit is the spring of all my desire for You.
Please bring my wants into harmony with Yours. Amen.

CHOSEN TO REJOICE

I write these things to you who believe in
the name of the Son of God so that you
may know that you have eternal life.
1 JOHN 5:13 NIV

Is your joy flagging? Are you feeling despondent about the life you've been handed? Nothing brightens a day like a gift wrapped in ribbons and bows. God's gift to you may not be wrapped in designer paper, but He is handing out the best gift you'll ever receive—eternal life—when you believe in the name of His Son, Jesus. It's earth-shattering news that should rattle your world. Death is not the end but only a doorway. Your real life with God begins when You believe, and it will never end. Allow this truth to put joy in your heart today.

. .

Jesus, You gave everything so that I could
be with You forever. Thank You! Amen.

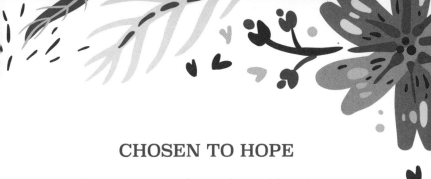

CHOSEN TO HOPE

"I have come as Light into the world, so that no one who believes in Me will remain in darkness."

JOHN 12:46 NASB

Hope is born! And we desperately need it. The message of Jesus' birth is not just one for the Christmas season. Friend, no matter what difficult or desperate circumstances you're facing, Jesus offers hope. He doesn't promise a perfect, comfortable life or that you'll get everything you want. Instead, He offers Himself as your hope—the light that pierces the dark. Hope that you have a loving Savior who died to take away the burden of your sin. Hope that God works even the hard things together for our ultimate good when we walk in His ways.

Father, thank You for the precious gift of hope. I know that Your plan for me is good, my sins are forgiven, and I will live with You forever in heaven. Amen.

TRUST

"Look at the birds in the sky. They do not plant seeds. They do not gather grain. They do not put grain into a building to keep. Yet your Father in heaven feeds them! Are you not more important than the birds?"

MATTHEW 6:26 NLV

Step outside and listen. Do you hear the cheerful chatter of the birds or see a flash of a bright wing in the foliage? Birds thrive through no trouble or toil of their own. Chosen one, never doubt that you are far more precious to your Father than a tiny songbird. But giving Him our trust even in the small things means abandoning our worry and obsession over what's going to happen tomorrow, how long we'll live, or what mark we'll leave behind. Embrace trust today.

* * *

Father, You've given me life and this beautiful world I live in. Help me to trust that You can do anything for me. Amen.

COME

*"Come, all you who are thirsty, come to the waters;
and you who have no money, come, buy and eat! Come,
buy wine and milk without money and without cost.
Why spend money on what is not bread, and your labor
on what does not satisfy? Listen, listen to me, and eat
what is good, and you will delight in the richest of fare.
Give ear and come to me; listen, that you may live."*

<small>ISAIAH 55:1–3 NIV</small>

We have to do only one thing to find mercy with God—come.
Isaiah says to eat what is good, no payment required. Put down
the empty satisfaction of the world. Come. Delight in the feast
that is the Gospel message of Jesus.

· ·

*Father, I've tried taking in the things that this
world spreads before me. They look delicious
but offer no sustenance for my soul. Amen.*

GO WITH GOD

*I hear the Lord saying, "I will stay close to you, instructing
and guiding you along the pathway for your life. I will advise
you along the way and lead you forth with my eyes as your
guide. So don't make it difficult; don't be stubborn when I
take you where you've not been before. Don't make me
tug you and pull you along. Just come with me!"*
PSALM 32:8–9 TPT

Friend, even when you feel alone in this life walk, the
encouraging truth is that you're not! God promises to stay
close to you and give you advice. He would guide you into His
chosen plans for you, but He'd rather not have to drag and
prod you forward like a headstrong mule. Are you stubbornly
resisting God's leading today?

*Father, give me a willing spirit and courage
to follow wherever You lead. Amen.*

FAITH INTO LOVE

Devote yourselves to lavishly supplementing your faith with goodness, and to goodness add understanding, and to understanding add the strength of self-control, and to self-control add patient endurance, and to patient endurance add godliness, and to godliness add mercy toward your brothers and sisters, and to mercy toward others add unending love. Since these virtues are already planted deep within, and you possess them in abundant supply, they will keep you from being inactive or fruitless in your pursuit of knowing Jesus Christ more intimately.

2 PETER 1:5–8 TPT

Meeting Jesus should transform your heart. And the more you get to know Him the more You'll want to work to be like Him—because what you do is the evidence you've been forever changed. What are you devoting yourself to today?

. .

Father, I want to grow closer to You and mature.
I want to bear the fruit of knowing You.
Nurture my faith into unending love. Amen.

45

CLAIMED

For this reason, beloved ones, be eager to confirm and validate that God has invited you to salvation and claimed you as his own. If you do these things, you will never stumble. As a result, the kingdom's gates will open wide to you as God choreographs your triumphant entrance into the eternal kingdom of our Lord and Savior, Jesus the Messiah.

2 PETER 1:10–11 TPT

I love the picture this verse stirs in my imagination. That God extends a hand to you and leads you onto the dance floor of life. He has choreographed all the moves, and supports you so that you don't stumble. All you have to do is let Him lead, and He will dance you right into eternity with the One who saved You.

. .

Father, You've claimed me as Your own. I belong to You. Strengthen me to choose love over offense every day. Amen.

FOREIGN EMISSARY

*Dear friends, I urge you, as foreigners and exiles,
to abstain from sinful desires, which wage war against
your soul. Live such good lives among the pagans that,
though they accuse you of doing wrong, they may see
your good deeds and glorify God on the day he visits us.*

1 PETER 2:11–12 NIV

A foreigner's homeland is in another place. You can usually peg them by their speech patterns, clothes, or behavior. They're not quite like everyone around them. So be encouraged when you don't fit into this culture very well. The fact that you're different is merely evidence that this world isn't your forever home. Your citizenship is in God's city, and that longing you feel is homesickness. Don't worry about assimilating. Instead, live God's love in front of your neighbors, and they'll be attracted to His grace.

. .

*Father, my true home is with You. Give me strength and
courage to stand out and draw others to Your love. Amen.*

MYSTERY OF THE HEART

*The heart is deceitful above all things
and beyond cure. Who can understand it?*
JEREMIAH 17:9 NIV

Apart from Christ, our emotions can deceive us. They whisper that forgiving is too hard, our situation hopeless, or our anger justified. Doing the right thing often means defying how you feel. Without Christ our hearts are desperately sick, but God rubs out the etchings of sin on the stony hearts of those who turn to Him and writes His law there instead. "At one time you were held by the power of sin. But now you obey with all your heart the teaching that was given to you. Thank God for this!" (Romans 6:17 NLV).

. .

*Father, I know what You say is right, but my emotions
sometimes win the day. Give me self-control and the
will to deny my feelings when they would lead me into
sin. Write Your words on my heart instead. Amen.*

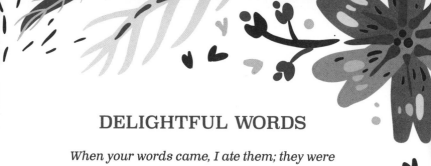

DELIGHTFUL WORDS

*When your words came, I ate them; they were
my joy and my heart's delight, for I bear
your name, LORD God Almighty.*

JEREMIAH 15:16 NIV

Jeremiah was a prophet during a time when God's people were faithless and worshipping false idols. He lived a difficult life in the midst of persecution. While we may not build altars to images carved in wood and stone today, we build a lot of other things that steal our affections from God. We amass wealth and chase after comfort and our own pleasure. But Jeremiah refused to join the revelers. Instead, he feasted on God's words and was nourished. His delight was living God's way, and joy flooded his heart even in dark times. Grab your Bible and rediscover joy in His Word today.

. .

*Heavenly Father, people around me are searching
for hope. Make Your Word my joy and happiness
so others will see the hope I have in You. Amen.*

THIRSTING FOR MORE

*As the deer pants for streams of water, so my
soul pants for you, my God. My soul thirsts for God,
for the living God. When can I go and meet with God?*
PSALM 42:1–2 NIV

Water is the one thing our bodies can't survive long without. Thirst is a driving need that can leave us single-mindedly focused on one thing—finding water. Do you seek after God with a driving desire and the knowledge that you can survive only a short time without Him? Jesus offers us living water that will satisfy our parched souls, life in the face of death, peace in turmoil, rest in a chaotic world. When you drink of His love, grace, and forgiveness you'll never look elsewhere for satisfaction.

* *

*Father, I need You. My soul thirsts for more of You.
Keep me from returning to drink from empty wells. Amen.*

REKINDLE YOUR JOY

*My beloved ones, don't ever limit your
joy or fail to rejoice in the wonderful
experience of knowing our Lord Jesus!*
PHILIPPIANS 3:1 TPT

Is Jesus enough in your world to provoke inextinguishable joy? Sometimes we lose sight of the seriousness of our situation without Jesus. In his classic *The Pilgrim's Progress*, John Bunyan wrote of a man named Christian who, upon learning of his impending doom because of sin, left his life and family and suffered many trials to find relief from this burden and escape judgment. Our future without Jesus is bleak. In fact, it's hopeless. But we've been saved. And more than that, we're adopted! God doesn't just open the prison gates and release us in rags to our own devices. He brings us into His house, to a waiting seat at His table.

*Father, my joy is complete in
knowing Jesus my Savior. Amen.*

FOUND IN HIM

*But whatever were gains to me I now consider loss for the
sake of Christ. What is more, I consider everything a loss
because of the surpassing worth of knowing Christ Jesus my
Lord, for whose sake I have lost all things. I consider them
garbage, that I may gain Christ and be found in him.*

PHILIPPIANS 3:7–9 NIV

Before he came face-to-face with Jesus on the road to Damascus, the apostle Paul was grasping to climb the ladder of status. But he learned that his value was in Jesus. In Philippians Paul says that by Jewish standards he was the best, but after he met Jesus his scales were turned on their head—he now considered his accomplishments garbage. He dumped everything he once thought was valuable in order to know Christ in all of His greatness.

. .

*Lord Jesus, knowing You is
priceless beyond compare. Amen.*

IN THE FACE OF FEAR

*For God did not give us a spirit of fear. He gave us
a spirit of power and of love and of a good mind.*
2 TIMOTHY 1:7 NLV

Are you a runner? Do you turn tail at the first sign of shaking knees, sweaty palms, and a racing heart? Fear is definitely one of Satan's favorite attacks to take you down. When we believe the enemy's lies instead of God's truth, fear gains a foothold. In her book *Do It Afraid*, Joyce Meyer tells readers that fear will try to steal your future, so you need to confront it head-on. If you let fear keep you from moving forward in life, you will miss God's best plans for you.

. .

*Father, give me courage to move forward
into Your plans in the presence of fear. Amen.*

*Joyce Meyer, *Do It Afraid* (New York: FaithWords, 2020), 51.

UNLEASH HIS LOVE

For we remember before our God and Father how you put your faith into practice, how your love motivates you to serve others, and how unrelenting is your hope-filled patience in our Lord Jesus Christ. Dear brothers and sisters, you are dearly loved by God and we know that he has chosen you to be his very own.

1 Thessalonians 1:3–4 tpt

Paul knew the faith of the Thessalonian believers was genuine because he saw the evidence of their faith in how they were living. Does your life give evidence to those around you that you belong to God? Put your faith into practice today. Love on your neighbors by dropping off a meal. Send some encouraging cards or a gift basket to the residents of a nursing home. The world will see and know that you are one of God's chosen.

* *

Lord, unleash Your love in my heart and allow it to motivate me to serve others. Amen.

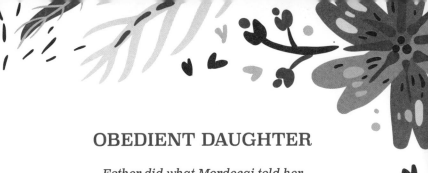

OBEDIENT DAUGHTER

Esther did what Mordecai told her
just as she had when under his care.
ESTHER 2:20 NASB

I almost breezed right by this unassuming verse in Esther. But take a moment to stop and digest it. Esther was obedient to Mordecai, her guardian after the death of her parents. God's plans for not only Esther's life but also the future protection of His people from genocide—a people through whom the Messiah would come—hinged on Esther's obedience to Mordecai. Our obedience carries weight. It's vital to cultivate habits of obedience to God in even the small things or we'll miss our part in His incredible plans. You were born "for such a time," just like Esther. Don't miss out on the destiny God has in store for you by ignoring His direction.

· ·

Father, show me the ways I have not been obedient to You.
Give me courage to do what You ask in all things. Amen.

PRICELESS TREASURE

*You are a people holy to the LORD your God. Out of
all the peoples on the face of the earth, the LORD
has chosen you to be his treasured possession.*
DEUTERONOMY 14:2 NIV

Through Christ this Old Testament promise holds true for all
believers. We've been grafted into the vine by the Vinedresser
to share in the hope that was born into the world with Jesus.
You are his treasured possession. And He takes exquisite care
to cherish and protect those who faithfully serve Him. The
Hebrew word used here describes a guarded wealth—something
of such extraordinary value that it must be protected under
lock and key. You, as a believer in Christ, are a unique and
priceless treasure to God.

*Father, You've chosen me as a treasure. I trust You to work
out Your plans, even through trials, for my ultimate good.
I know that You will take special care of me. Amen.*

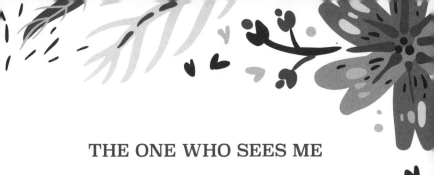

THE ONE WHO SEES ME

She gave this name to the LORD who spoke to her:
"You are the God who sees me," for she said,
"I have now seen the One who sees me."
GENESIS 16:13 NIV

Abraham and Sarah, tired of waiting on the Lord to fulfill His promise of a son, cooked up their own plan to have a child through their servant Hagar. But as soon as Hagar discovered she was pregnant, she rubbed the news in Sarah's face. And Sarah dealt a harsh tongue-lashing that sent Hagar running. God found her, and in spite of a petty spat between women, He kept His promise to bless Abraham's offspring. He saw Hagar. And He sees your problems too.

. .

Father, I know You see me—everything I feel, my sins,
and every mistreatment I've suffered. You're always
there to listen and give me direction. Thank You. Amen.

CAPTURE EVERY THOUGHT

*We demolish arguments and every pretension that sets
itself up against the knowledge of God, and we take
captive every thought to make it obedient to Christ.*
2 CORINTHIANS 10:5 NIV

The enemy battles daily for your mind. If Satan can control your thoughts, he can control your actions. But the Bible warns us to take captive every thought. We have thousands of thoughts every day, and it's vital that we recognize when we're being tempted by thoughts that are not pleasing to God. The Bible says, "As [a man] thinks in his heart, so is he" (Proverbs 23:7 NLV). This choice is a battle. And when you confront Satan's lies with scripture and change your thoughts, you've captured that thought and made it obedient to Christ.

*Father, make me acutely aware of the thoughts
that enter my mind today. Fill my mind with Your
Word so I know what pleases You. Amen.*

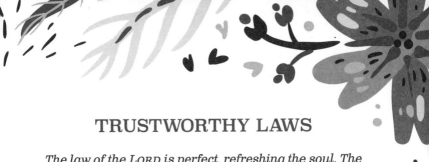

TRUSTWORTHY LAWS

*The law of the LORD is perfect, refreshing the soul. The
statutes of the LORD are trustworthy, making wise the simple.*
PSALM 19:7 NIV

Sheep are vulnerable to many dangers out in the pasture—
wandering off, injury, and predators. Shepherds worked hard
to protect their sheep and would gather them into walled
sheep pens for the night, where the shepherd would sleep
in the doorway. The walls contained the sheep, yes, but not
because the shepherd wanted to squash their freedom, rather,
because he loved his sheep and wanted them safe. God's laws
sometimes feel prohibitive to our self-seeking, independent
human minds. But it's vital to our spiritual survival to re-
member the truth—the boundaries of God's laws protect us;
they give us life. The borders of His instruction are good and
trustworthy.

. .

*Lord, teach me obedience, because my rebellion against
Your instruction leads me into destruction. Amen.*

SHINE

Be glad you can do the things you should be doing. Do all things without arguing and talking about how you wish you did not have to do them. In that way, you can prove yourselves to be without blame. You are God's children and no one can talk against you, even in a sin-loving and sin-sick world. You are to shine as lights among the sinful people of this world.

PHILIPPIANS 2:14–15 NLV

The cure for the grumps is thanksgiving. When you're feeling too tired to wash the dishes, stop and praise God that you have dishes to eat from and delicious food to eat off them. When your alarm startles you awake for a job you don't enjoy, thank God for providing you with an income. Others will definitely notice that you're different if instead of complaining you praise God for every blessing!

* * *

Father, help me guard my tongue against complaining today. Amen.

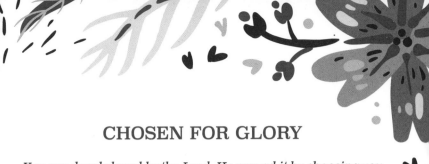

CHOSEN FOR GLORY

*You are dearly loved by the Lord. He proved it by choosing you
from the beginning for salvation through the Spirit, who set
you apart for holiness, and through your belief in the truth. To
this end he handpicked you for salvation through the gospel
so that you would have the glory of our Lord Jesus Christ.*
2 THESSALONIANS 2:13–14 TPT

Take a moment to consider the fantastic truth these verses
contain for those who believe in Christ. From the beginning God
set in motion an extraordinary plan and chose us for wonderful
things—a Father's deep love, salvation through Jesus, the gift
of His Holy Spirit. He set us apart for holiness, and His goal
was not merely removing our burden of guilt but enabling us
to share in the glory of Jesus.

· ·

*Father, thank You for all that You've done for
me and for choosing me from the beginning
to share in Christ's glory. Amen.*

ABIDE

*"Abide in me, and I in you. As the branch cannot
bear fruit by itself, unless it abides in the vine,
neither can you, unless you abide in me."*

JOHN 15:4 ESV

Jesus encourages believers to build a daily relationship with Him—a real friendship of conversation, trust, and enjoyment. Talk to Him through constant prayers, trust Him to care for and guide You, listen to His direction, obey Him, and experience the joy of His salvation. Take a moment to slowly read through the definitions for the Greek word translated as *abide*: "to continue, dwell, endure, be present, remain, stand, tarry." Which word is most meaningful in your relationship with Jesus? Which aspect would you like to cultivate more?

· ·

*Father, I want to abide or be present with You
every moment. Help me to tarry with You daily. Amen.*

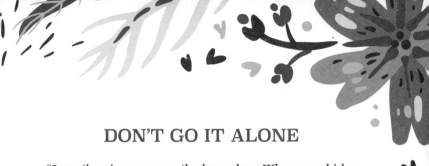

DON'T GO IT ALONE

"I am the vine; you are the branches. Whoever abides
in me and I in him, he it is that bears much fruit,
for apart from me you can do nothing."
<small>JOHN 15:5 ESV</small>

We all need a daily dose of Jesus. That's why He encourages believers to abide: to live for Him, trust in Him, pray continually, and be about the Father's business instead of becoming distracted by our own desires. We can't do kingdom work without Him. Sure, we can check off to-do lists and survive, we might even enjoy ourselves, but we can't accomplish anything of eternal kingdom value without Jesus in our lives. Through the Holy Spirit we have the mind of Christ. Think like Jesus today and step forward into your role in God's story.

* *

Father, without You in the center of my life,
every action I take is meaningless. Teach me
to abide and rely fully on You. Amen.

HE IS OUR PEACE

He will be great to the ends of the earth.
And He will be their peace.
MICAH 5:4–5 NLV

Many of us just want a moment of peace and quiet, but we live in a culture that creates chaos. Stress, anxiety, and busyness throw our lives out of control. But a nonstop stress fest isn't what God intended. God desires us to have peace. Just as parents eagerly anticipate their children's joy on Christmas morning when they tear through wrapping paper and scatter bows from the presents they've carefully picked for them, God is excited for you to have peace. And our one source of unshakable peace is Jesus.

Lord, show me the false peace I've been relying on to get by.
Teach me to trust in Jesus instead. Amen.

EYES OPEN

But who can discern their own errors? Forgive my
hidden faults. Keep your servant also from
willful sins; may they not rule over me.
Psalm 19:12–13 NIV

I make a lot of mistakes—too many. You probably do too if you're being totally honest. Some I'm painfully aware of, like losing my temper or making a rude comment to an irritating person. Maybe I wasn't 100 percent honest or a bit of gossip rolled off my tongue. But other times I do things without thinking and I don't even acknowledge my own pride or selfishness. God loves us and forgives us, even the sins we don't recognize. But He also wants us to pay attention and live right so we can be an example to others and avoid unpleasant consequences.

Father, help me to pay more attention, and show me
any sins that have been hiding out in my life. Amen.

DO YOU BELIEVE?

"For here is the way God loved the world—he gave his only, unique Son as a gift. So now everyone who believes in him will never perish but experience everlasting life."
JOHN 3:16 TPT

Beloved, God longs for you to be His daughter. Do you believe that Jesus is God's Son who lived a perfect life, died for your sins, and rose on the third day—that He did this so you could live in everlasting relationship with Him? He came to rescue you from punishment for every poor choice, misstep, and headstrong mistake. The steps into heaven are simple, yet many stumble over them: "If you say with your mouth that Jesus is Lord, and believe in your heart that God raised Him from the dead, you will be saved" (Romans 10:9 NLV). Do you believe?

. .

*Father, I believe! The depth of your love is stunning,
that You would sacrifice so much for me. Amen.*

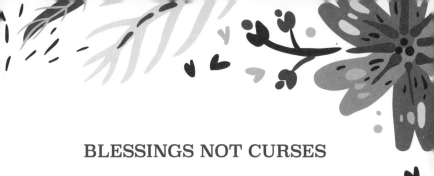

BLESSINGS NOT CURSES

When someone does something bad to you, do not do the same thing to him. When someone talks about you, do not talk about him. Instead, pray that good will come to him. You were called to do this so you might receive good things from God.

1 PETER 3:9 NLV

Oh, how you want to give her a piece of your mind! That woman's veiled insults have really gotten under your skin. But the words of this scripture filter through your anger. You don't want to pray for her when you feel like yelling, but God's law is not retaliation—it's love. This is no easy choice. But remember that your choice to love is also a choice to trust God, knowing that He will work all things—even your pain—in His way and His unerring time.

. .

Father, give me self-control. Getting even doesn't bring glory to You, no matter how justified I feel in the moment. Amen.

HE IS ABLE

Now to him who is able to do immeasurably more than all we ask or imagine, according to his power that is at work within us, to him be glory in the church and in Christ Jesus throughout all generations, for ever and ever! Amen.
EPHESIANS 3:20–21 NIV

God created us to depend on Him to meet our needs. We humans like our independence and even imagine that we can take care of ourselves pretty well. But the moment things beyond our control assault us, the reality of our helplessness becomes obvious. But friend, don't be afraid, for God will never let you down, leave you, or forsake you. Not only is He capable and willing to meet our needs, but scripture promises that He is able to do way more than we can even imagine, so much more than we think to ask.

Father God, thank You for keeping Your promises to meet all of my needs, both spiritual and physical. Amen.

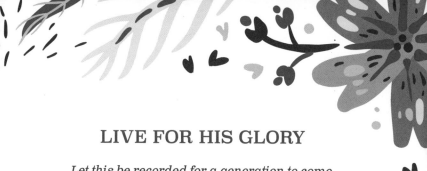

LIVE FOR HIS GLORY

Let this be recorded for a generation to come,
so that a people yet to be created may praise the LORD.
PSALM 102:18 ESV

You were created by a great and loving God. His longing to create you, beloved, was deep. He formed you with purpose and intent, shaping the contours of your personality, igniting the spark that is you—with every special talent, every deep desire, and every good work that was ordained just for you. It's no accident that you're here. Your life has been on the books back through the generations. He has been waiting for you. And one of His greatest purposes for your life is to bring Him glory. What are you doing right now with this precious life He has given you so that future generations will praise the Lord?

Heavenly Father, You made me in Your image to
reflect Your love into a dark world. How can
I bring glory to Your name today? Amen.

STAND IN THE LIGHT

But you are a chosen people, a royal priesthood,
a holy nation, God's special possession, that you
may declare the praises of him who called you
out of darkness into his wonderful light.

1 PETER 2:9 NIV

As a beloved daughter of the Most High King, walk in His wonderful light for all the world to see. Today, Christian values are often mocked and even considered hateful. Peter warned us that we are to live godly lives among those who do not follow God. By doing right, no matter what, you bring glory to God. Do good and follow Jesus' example for God's glory, even if it means suffering as He did. Have you kept quiet or changed your behavior lately in the company of the ungodly?

. .

Father, You've called me into your marvelous
light to live holy. Give me courage to choose
Your ways, even in the face of censure. Amen.

SUPERNATURAL SUPPORT

David said to the Philistine, "You come against me with sword and spear and javelin, but I come against you in the name of the LORD Almighty, the God of the armies of Israel, whom you have defied. This day the LORD will deliver you into my hands."

1 SAMUEL 17:45–46 NIV

Goliath was a bully. And by outward appearances, he should have taken David down. Life is full of bullying people and circumstances. And fear is the biggest giant of them all. But God loves to prove His own might and worthiness by winning victories through the weakest vessels. So take courage, straighten your spine, meet the cold eyes of fear, and step forward to confront him—you can because God is with you. And "greater is He who is in you than he who is in the world" (1 John 4:4 NASB).

. .

Father, I can win against desperate circumstances because the battle is Yours. Amen.

CHOSEN FOR JOY

I delight greatly in the LORD; my soul rejoices
in my God. For he has clothed me with garments of
salvation and arrayed me in a robe of his righteousness.
ISAIAH 61:10 NIV

Beloved daughter, your heavenly Father longs for a deep relationship with You. He wants your life to shine before the world as a beacon—proof that He has changed you and made your life better. Your sins are forgiven, and you will live eternally with a God who loves you immensely and delights in your presence, so let your joy overflow! When joy permeates your life, people will notice. And they may even ask what makes you different. Be ready this week to encourage the world through your joy.

Father, thank You so much for saving me! In light
of this knowledge, the struggles here cannot stifle
my joy. Show me who needs a smile today. Amen.

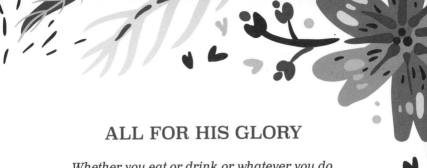

ALL FOR HIS GLORY

Whether you eat or drink or whatever you do,
do it all for the glory of God.
1 Corinthians 10:31 niv

Bringing glory to God is about so much more than what we do inside the walls of a church building. Church work is important, and we're urged not to give up meeting together, but God wants more than just a piece of you—more than just your Sunday morning devotion—He wants all of you. Whatever you do, do it all for His glory. God is glorified when you help your neighbor; He is glorified when you act with integrity; He is glorified when you do a job to the best of your ability. Are all the things you're doing bringing glory to God? How can you bring Him glory in whatever you do?

Father, help me to bring You glory in everything
I do. Show me attitudes and activities in my
day that don't honor You. Amen.

A THRILL OF HOPE

*"The people living in darkness have seen a
great light; on those living in the land of the
shadow of death a light has dawned."*
MATTHEW 4:16 NIV

O holy night! The stars are brightly shining;
It is the night of our dear Savior's birth.
Long lay the world in sin and error pining,
Till He appeared and the soul felt its worth.
A thrill of hope—the weary world rejoices,
For yonder breaks a new and glorious morn!

It may not be anywhere near December 25th, but the birth
of hope into the world isn't really a seasonal celebration.
Celebrate hope today no matter what day it is. Ponder the
words of this carol and feel the light of hope burst brightly into
dark circumstances. Renew your hope through faithful trust
in God's wonderful salvation of the world, His Son.

. .

Father, thank You for Jesus, who takes
away the sin of the world. Amen.

TRUST HIS PROVISION

My God will supply every need of yours
according to his riches in glory in Christ Jesus.
PHILIPPIANS 4:19 ESV

George Müller founded an orphanage in Bristol, England, in 1836 without asking people for a single resource. His trust in God's provision is inspirational. He prayed daily to ask God for everything they needed, trusting in God's ability to provide—and He did many times over. God has showered us with examples in scripture of His provision—everything from an ark to manna from heaven—but are you living today like you believe Him capable of supplying your needs? Trust is believing what someone says and knowing that they'll keep their word. Look up George Müller's story today and be inspired to trust God more fully.

. .

Father, forgive me for turning to other sources
or indulging anxiety when I'm in need. I know
that I can ask You to provide. Amen.

RESTORING
BROKEN FELLOWSHIP

*Because they would not keep God in their thoughts
anymore, He gave them up. Their minds were sinful and
they wanted only to do things they should not do. They are
full of everything that is sinful and want things that belong
to others. They hate people and are jealous. They kill other
people. They fight and lie. They do not like other people and
talk against them. They talk about people, and they hate God.*

ROMANS 1:28–30 NLV

When knowing God isn't the most important priority in our
lives, much like Christian in *The Pilgrim's Progress*, we wander
off the path to the Celestial City and deadly sins creep into
our thoughts and actions. Search your heart as you read today's
verses. Do you need to confess and ask forgiveness for any of
these sins?

. .

*Father, forgive me for straying. Restore my
broken fellowship with You. Amen.*

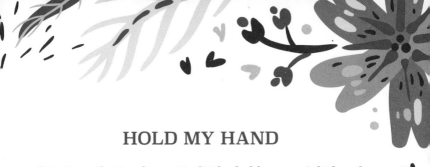

HOLD MY HAND

"For I am the Lord your God Who holds your right hand, and Who says to you, 'Do not be afraid. I will help you.'"
ISAIAH 41:13 NLV

We're under a lot of pressure to perform—raising godly children, keeping a clean house, staying fit, volunteering, working in the church, caring for relatives. Do you try to do it all yourself? All of these are good things, but the Lone Ranger mindset that we must bulldoze through alone, not trusting anyone but ourselves, is a dangerous one. The secret to true strength is coming to the end of yourself and realizing that *you can't,* but *God can.* And, friend, He loves you. He will hold your hand and help you. Take a moment and ask Him for the help you need today.

. .

Father, I need Your strength today. I need more of Your patience and love because my tasks seem too much for me. Amen.

GOD'S GOOD INTENTIONS

*"You intended to harm me, but God intended
it for good to accomplish what is now
being done, the saving of many lives."*
GENESIS 50:20 NIV

The things that happen to us don't always make sense in the moment. Joseph's brothers threw him into a well, from which he was retrieved and then sold as a slave. He probably didn't understand this painful turn of his life's events, but He did choose faith and trust in a God who promises to work even the most devastating blow for good—*if* we choose to love God in spite of our pain and live right. From the ashes of jealousy God wrought forgiveness, reconciliation, and new life. He can accomplish great things through your trials too if you love Him and live faithful to His ways.

*Father, thank You that even when people want
to hurt me, I can rest in the knowledge that You
can bring about good from the bad. Amen.*

WHAT IS LOVE?

"If you love me, you will keep my commandments."
JOHN 14:15 ESV

The meaning of love in today's world has become a murky pool with even less defined borders. When we forget scripture and fail to consult God, we're left to scramble with only a human understanding of what it means to love. But God is clear about what our love for Him should look like—to love Him is to obey Him. The length of our obedience and the depth of our love are directly related when it comes to our heavenly Father. And Jesus even simplified God's rules beautifully for us: Love the Lord with all your heart, soul, mind, and strength, and love others as you love yourself. Do you love Him? Show Him today through obedience.

. .

Lord, I love You! I choose obedience
because my heart belongs to You. Amen.

ATTRACTED BY GRACE

*Jesus said to them, "It is not the healthy
who need a doctor, but the sick. I have not
come to call the righteous, but sinners."*
MARK 2:17 NIV

Jesus drew the condemnation of many religious leaders for hanging out with the wrong crowd. Do you generally befriend only people who are like you? It's natural to feel comfortable around others who share similarities with us and avoid people whose differences make us hesitant to connect. But Jesus did things differently. He didn't care who was the most popular, the brightest, or the richest. And He never worried about ruining His reputation by dining with sinners. He cared about their problems more than their mistakes and brought hope to their wretched state. His grace attracted them to His truth.

* *

*Lord, thank You for loving the marginalized,
the undesirables, like me. Give me courage to share
Your love no matter what I see on the outside. Amen.*

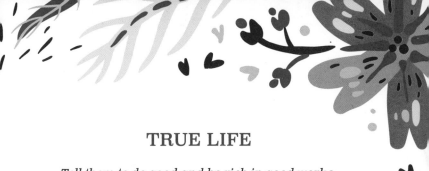

TRUE LIFE

Tell them to do good and be rich in good works.
They should give much to those in need and be ready to
share. Then they will be gathering together riches for
themselves. These good things are what they will build
on for the future. Then they will have the only true life!
1 TIMOTHY 6:18–19 NLV

You probably don't struggle with intense hatred for others. But it's been said that the opposite of love is not hate but indifference. Have you ever been indifferent to the problems of others? Often we don't lift our attention from the grindstone of our struggles and ambitions. But, friend, it takes only a few minutes out of a busy day to stop and chat with a lonely neighbor. Have you looked around you lately?

. .

Lord, lift the veil of my own concerns from
my eyes. Give me eyes to see the hurt and
needs of the people You love. Amen.

PEACE OF MIND

*He shall stand and shepherd his flock in the strength
of the LORD, in the majesty of the name of the LORD
his God. And they shall dwell secure, for now he
shall be great to the ends of the earth.*

MICAH 5:4 ESV

What must it have been like for the Jewish people to wait in hopeful expectation of a prophecy, the birth of a promised king? They wanted political sovereignty, but God had plans for so much more than a fleeting earthly kingdom. Instead of the crown jewels, Jesus donned a crown of thorns, and instead of brokering peace treaties, Jesus brought everlasting peace to the hearts of all people who proclaim Him Lord of their lives. Are there certain spaces in your heart you haven't surrendered to Christ?

* * *

*Father, show me where I have resisted
Your governing Spirit in my life. Amen.*

SWEET ADVERSITY

Be joyful in hope, patient in affliction, faithful in prayer.
ROMANS 12:12 NIV

Life can be hard and ugly. Sometimes we're stuck in a season of tears that requires both grit and tissues. And we often ask God why this shadow has dropped over us like an unrelenting black shroud. Charles Spurgeon answered the age-old question with this encouragement: "Dost thou not know that hope itself is like a star—not to be seen in the sunshine of prosperity, and only to be discovered in the night of adversity? Dost thou not understand that afflictions are often the black foils in which God doth set the jewels of his children's graces, to make them shine the better." The light of hope is best seen through the darkness. What dire circumstances can you ask God to turn into hope today?

. .

Father, teach me to hope. In the midst of
difficulty I will faithfully trust in You. Amen.

THINGS ABOVE

Since, then, you have been raised with Christ,
set your hearts on things above, where Christ is,
seated at the right hand of God.
<small>COLOSSIANS 3:1 NIV</small>

A rich young man once asked Jesus what he could do to obtain eternal life, but he wasn't happy with the answer. "If you want to be complete, go and sell your possessions and give to the poor, and you will have treasure in heaven; and come, follow Me" (Matthew 19:21 NASB). The Greek word *complete* used in this verse means "finished, full-grown, fully developed, and lacking any deficiencies or shortcomings." If we wish to reach our maturity as followers of Christ, our love must blossom into the maturity of God's love. What are you holding on to that's hindering your growth?

. .

Lord, I know that You will carry on toward
completion the good work you started in
me until the day of Christ Jesus. Amen.

SPEAK LIFE

Do not let any unwholesome talk come out of your mouths,
but only what is helpful for building others up according
to their needs, that it may benefit those who listen.
EPHESIANS 4:29 NIV

Words are a powerful force that we should handle with the caution of a bomb technician. Mere syllables contain the power to build or destroy, to bless or defile. So speak God's words, agree with His plans and purpose for your life and the lives of those around you. Don't allow the habits of negativity and criticism to become entrenched in your mind. Are the words you've been saying a benefit to others, or do people cringe when you open your mouth? If you're leaving a wake of destruction behind your every sentence, ask the Holy Spirit to renew your mind, and commit to encouraging one person today with edifying words.

Lord, teach me to speak life. Put Your words
of encouragement in my mouth. Amen.

RESIST SIN

*Do not let sin reign in your mortal
body so that you obey its evil desires.*
ROMANS 6:12 NIV

Brother murdered brother—Adam and Eve probably never considered the devastating price of their sin in the garden of Eden. I'm sure they never imagined they'd pay so dearly. But Satan deals in half-truths and deception. He is cunning and wants us to believe that indulging in passions and lusts is worth it. He mixes in a bit of truth because sin *can* be pleasurable— for a moment. But the enemy never reveals the bill until after the party. And the price tag for our sin can be more than we're willing to pay—our marriage, our kids, our integrity. But there's hope for us! Scripture says that we won't be tempted beyond what we can bear. Beloved, call out for help from the Holy Spirit.

*Father, open my eyes. Don't allow me to be blindsided
by the devastating long-term consequences of sin. Amen.*

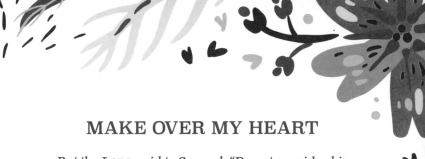

MAKE OVER MY HEART

But the LORD said to Samuel, "Do not consider his
appearance or his height, for I have rejected him. The LORD
does not look at the things people look at. People look at the
outward appearance, but the LORD looks at the heart."
1 SAMUEL 16:7 NIV

Wrinkles may form ranks on our faces as we age, but don't
fret, friends. God never judges a book by its cover. He is more
interested in the look of your heart. "Do not lose heart. Though
our outer self is wasting away, our inner self is being renewed
day by day" (2 Corinthians 4:16 ESV). Spend more time in
scripture than doing sit-ups and in prayer than doing Pilates.
After all "the imperishable beauty of a gentle and quiet spirit"
is very precious to God (1 Peter 3:4 ESV). Is your heart beautiful
to God?

* *

Father, show me any place in my heart
that's in need of a makeover. Amen.

LIVING WORD

For the word of God is living and active, sharper than any two-edged sword, piercing to the division of soul and of spirit, of joints and of marrow, and discerning the thoughts and intentions of the heart.

HEBREWS 4:12 ESV

Imagine a time when owning a copy of the Bible in English was a crime. But William Tyndale wanted all Englishmen to read God's Word for themselves. Forced out of England by opposition, he translated the New Testament scriptures in Germany, and copies of his work were smuggled into England. Eventually Tyndale was arrested and executed for his work to bring God's Word into the English language. Consider Tyndale's great love of scripture and willingness to share it with others, no matter the cost. Tyndale wanted all people to experience scripture's power to transform lives. Are you as willing to share scripture with those around you?

Father, Give me courage to share Your Word. Amen.

HEAVEN'S WISDOM

*Wherever you find jealousy and fighting, there will
be trouble and every other kind of wrong-doing. But
the wisdom that comes from heaven is first of all pure.
Then it gives peace. It is gentle and willing to obey. It
is full of loving-kindness and of doing good. It has no
doubts and does not pretend to be something it is not.*

JAMES 3:16–17 NLV

William Penn once said, "The jealous are troublesome to others, but a torment to themselves." Envy smothers our ability to love well. Instead of rejoicing with those who rejoice, its bitter roots twine their way into our heart and choke out our charity for others. The world says that the success and happiness of others robs us of our good share of the pie, but the wisdom of God says His abundance knows no bounds.

. .

*Father, scour every speck of bitter envy from my heart.
Your abundance of blessings will never run dry. Amen.*

DEFEAT DOUBT

Then Jesus told him, "Because you have seen me,
you have believed; blessed are those who
have not seen and yet have believed."
<small>JOHN 20:29 NIV</small>

Doubting Thomas—not the most flattering nickname to have
hung around your legacy for millennia. Sure, Thomas wanted
physical proof that Jesus was indeed alive, but once he'd touched
those nail-scarred hands, he cried, "My Lord and my God!"
(John 20:28). The important fact that often gets overlooked is
that Thomas's doubt was transient. He had reservations, but
moved through them to faith and belief. Some historical records
even indicate that Thomas became a missionary to India and
was martyred there. We all have doubts at some point, but we
can take those thoughts captive. Bring them to Christ and allow
your unanswered questions to spur you on to spiritual growth.

* *

Father, strengthen my faith with the evidence
of You when uncertainty attacks. Amen.

THE ROCK

He is the Rock, his works are perfect, and all
his ways are just. A faithful God who does
no wrong, upright and just is he.
DEUTERONOMY 32:4 NIV

Every structure needs a foundation to hold it up, so skilled builders set their foundations on something solid. If you build on the sand, it will shift in the storms and wash out from under your foundation. The integrity of every building is only as good as its foundation. Wise people know that we'll all face hard things—our lives can be quite stormy. So they build on the Rock. God is dependable and durable like solid rock. Where are you building your life? In the sands of worldly ways or on the Rock?

. .

Father, teach me to follow the good plan I
find in Your Word and build my life on You—
the Rock who will never fail me. Amen.

HIDDEN IN MY HEART

*I have hidden your word in my heart
that I might not sin against you.*
PSALM 119:11 NIV

Theodore Roosevelt said, "A thorough knowledge of the Bible is worth more than a college education." Most of us have a few books lying around the house. But they won't benefit us at all if we never read them and use what we've gleaned. The same goes for the Bible—God's instruction manual. Today and every day we should clear some space to read and think about God's Word. And don't scurry to the rest of your day and forget what you've read—memorize it and use it. God's Word will keep you from sin (Psalm 119:11), protect you from lies (2 Timothy 3:13–15), and bring you peace and joy (Psalm 85:8; Jeremiah 15:16).

. .

*Father, I commit to making Your Word a priority
in my day and memorizing what it says. Amen.*

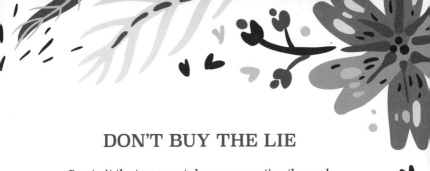

DON'T BUY THE LIE

*See to it that no one takes you captive through
hollow and deceptive philosophy, which depends
on human tradition and the elemental spiritual
forces of this world rather than on Christ.*
COLOSSIANS 2:8 NIV

Do you spend more time watching TV and reading and listening
to secular books and music than you do studying your Bible?
God wants to transform you into a new person by changing
the way you think, but the behavior of the world often does not
reflect God or His truth. If your time is consumed by listening
to lies from the enemy, pretty soon you'll start believing them.
God's Word warns us to beware of our culture's falsehoods and
to keep our eyes fixed on God's truth in scripture.

. .

*Father, reveal the lies I've been buying. Help me
cut out the leisure activities that don't glorify You.
Fill me with a great desire to bask daily in Your Word.*

HIDE SMART

God is good, a hiding place in tough times.
He recognizes and welcomes anyone looking
for help, no matter how desperate the trouble.
NAHUM 1:7 MSG

You roll out of bed, throw on some clothes, and beeline for the coffeepot. But before you even savor a single sip of your morning lifeline, trouble clotheslines you right out of the starting gate. On hostile days like this, hiding seems like a safe, maybe even wise, option. Just make sure you pick the right hiding place. God understands your frailties; He created you, after all. And He is prepared to be your hiding place. You don't even have to get back in bed and pull the covers up over your head. Instead, cover yourself with His grace, comfort, and peace.

Father, on my worst days I know I can hide out in You.
You're strong enough to handle my problems and
bring peace to my fearful thoughts. Amen.

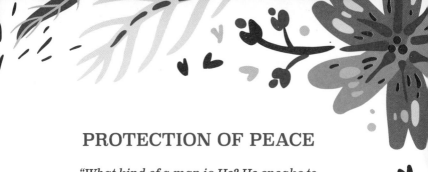

PROTECTION OF PEACE

*"What kind of a man is He? He speaks to
the wind and the waves and they obey Him."*
LUKE 8:25 NLV

When you feel as if your life is out of control and you are powerless and in pain, depression, stress, or anxiety; when a situation looks hopeless—your ship is sinking in the ravaging waves of sickness, divorce, or loneliness—remember that you know the One who calms vicious storms with the power of His voice. The same powerful voice that said, "Let there be…" and creation snapped into existence, can speak calm into your soul. His peace, which is beyond comprehension in this hostile world, will become an impenetrable wall surrounding your heart and mind. When you realize you have no control, remember that Jesus does.

. .

*Lord, may others see the peace with which
You enfold me and be drawn to You. Amen.*

LOVE THE UNLOVELY

If your enemy is hungry, give him food to eat;
if he is thirsty, give him water to drink.
PROVERBS 25:21 NIV

Who do you find hard to love? At our best we usually ignore those people, and at our worst we plot their downfall. It rubs against our grain to pray for their well-being and return kind words for insults. Jesus said that if the one who hates you is hungry, feed him. If he's thirsty, give him water. It's easy to be nice to people who treat you well. The real test is how you treat the ones who insult you or gossip about you or hurt you. Do you live God's way and treat others the way you'd like to be treated?

. .

Father, I will try to love those who treat
me poorly. Maybe I am Your chosen
vessel to introduce them to Jesus. Amen.

STAND FOR JUSTICE

But let justice roll on like a river,
righteousness like a never-failing stream!
AMOS 5:24 NIV

William Wilberforce was born into a wealthy family in 1759. He could have lived his whole life in the privilege of his station. But instead of amassing more riches and seeking his own pleasure, he chose to use his influence to right a grievous wrong—he fought diligently for the abolition of the slave trade. Wilberforce fought for the liberty of millions, and he died just days after the Slavery Abolition Act was set to pass. Do you see wrongs being committed against people around you? Are you willing to step from your comfort zone so that another person can receive justice?

. .

Father, increase my compassion toward humanity.
So many people are being abused, but You care for
the weak and marginalized. Help me to serve the
cause of justice in any way that I can. Amen.

SIN PIT

*See how the sinful man thinks up sins and plans trouble
and lies start growing inside him. He has dug out a
deep hole, and has fallen into the hole he has dug.*
PSALM 7:14–15 NLV

Do you know anyone who seems to revel in trouble? Gossip,
drama, and lies spread in her wake of hurt feelings and wrecked
relationships. Satan is the father of lies, and any time we allow
sin into our lives, his lies gain a deeper foothold. "She deserved
every word—after all, it was only the truth." "The nerve of her
expecting my help when she doesn't lift a finger." "I don't need
to forgive her. She's not even sorry!" Friend, don't fall into this
pit. Keep watch over your thoughts and whip them in line with
scripture. God wants you to experience the blessings of holy
living.

. .

*Father, help me guard my thoughts before they become sins.
Keep me from digging pits of wrong thinking. Amen.*

HE'LL NEVER GIVE UP!

*I'm fully convinced that the One who began this gracious
work in you will faithfully continue the process of maturing
you until the unveiling of our Lord Jesus Christ!*

PHILIPPIANS 1:6 TPT

Our heavenly Father paints a work of art with each of our lives
as we faithfully follow Him. He continues to mature our love,
grow our generosity, and increase our patience with each
passing day. Even when we mess up, we can find peace and joy
in knowing that He won't give up on us. Rest with the thought
that your Creator continues to add the defining strokes of His
brush that shape the masterpiece that is you.

. .

*Lord Jesus, I can't wait to see what beauty You
create from my life. Teach me obedience as
You complete Your good work in me. Amen.*

LETTING GO

"Be still, and know that I am God; I will be exalted among the nations, I will be exalted in the earth."
PSALM 46:10 NIV

It's difficult for me to let things be. After all, I'm chosen to *do* God's will. I'm a fixer, a doer, a mover and shaker. But sometimes my best intentions can make a mess of things. And other times I'm left feeling helpless because *I* can't change things. In Psalm 46:10 the Hebrew word for *still* means "to loosen, let fall, let drop, to withdraw." When God says for me to be still, He is actually telling me to drop it. And I need to drop to my knees in prayer and get out of God's way so He can move.

• •

Father, give me wisdom to know when to act and when to withdraw in prayer so You can do Your God thing. In Jesus' name, amen.

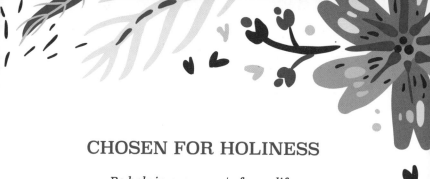

CHOSEN FOR HOLINESS

Be holy in every part of your life.
Be like the Holy One Who chose you.
1 PETER 1:15 NLV

God calls us to be holy because He is holy. It's quite easy to walk into church each week and put on your Sunday face. To pretend as if the rest of the week belongs to you and how you live those other six days is your business alone. But this verse doesn't say to be holy on Sunday or to be holy on the outside. It says, "Be holy *in every part of your life*." There are no loopholes in God's expectations. Your interactions with others, your thought life, the things you do in private are all a part of your spiritual integrity. Take inventory of your life for a moment. Are you holy in every part?

* *

Father, search my heart and show me where my
thoughts or actions have not been pure. Amen.

HE IS MY RIGHTEOUSNESS

My passion is to be consumed with him and not cling to my own "righteousness" based in keeping the written Law. My only "righteousness" will be his, based on the faithfulness of Jesus Christ—the very righteousness that comes from God.

PHILIPPIANS 3:9–10 TPT

Trying to be good enough for God will leave you discouraged and frustrated. Our failures weigh heavy on our backs. This mindset of earning God's favor can be sneaky. We have to examine our motivations carefully. Are you doing things out of love and a sense of God-directed purpose, or are you merely trying to earn your way into God's good graces? Beloved, you're already accepted. God now sees Christ's obedience as yours. And His grace is yours—free of striving for perfection.

* *

Jesus, thank You for living the obedient life that I can't. I'm overwhelmed with gratitude that You would die to cover my mess with Your pristine righteousness. Amen.

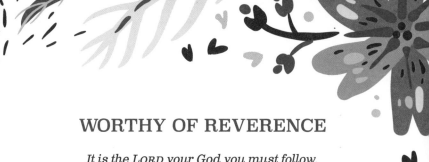

WORTHY OF REVERENCE

*It is the LORD your God you must follow,
and him you must revere. Keep his commands
and obey him; serve him and hold fast to him.*
DEUTERONOMY 13:4 NIV

Reverence is not a word we often use in today's culture. The world, caught up in glorifying self, has lost all sense of deep respect for our all-powerful Creator God. And the cancel culture we find ourselves engulfed in has left a pretty irreverent bunch. Will you choose to know more of Him, to love and obey Him? Or will you choose to make a god out of money, position, or power? Come closer to Him, friend. When you see for yourself how amazing God is, your heart will gladly reverence and honor Him.

. .

*Lord my God, thank You for showing me how wonderful
You are! I love You and want to serve You. Help
me to do only what pleases You. Amen.*

LOVE LETTER

He will have much joy over you. With His love
He will give you new life. He will have joy
over you with loud singing.
ZEPHANIAH 3:17 NLV

Oh, the sweet anticipation of reading the words of someone who loves you! Likely you keep them in a special place and read them over and over. We all want to feel cherished, to know someone cares, looks forward to seeing us, and thinks about us. How would you feel if God wrote you a love letter telling you how delighted He is with you? He did! The Bible is the story of His great love for you. You're special to Him, and He thinks about you all the time. Open your Bible and consider that God wants you to know Him as intimately as He knows you.

* *

Heavenly Father, Your love for me is unmatched.
I want to know You more. Amen.

HOMESICK

*Then the angel showed me the river of the
water of life, as clear as crystal, flowing
from the throne of God and of the Lamb.*
REVELATION 22:1 NIV

We're all longing for something better. C. S. Lewis wrote in
Mere Christianity, "If I find in myself desires which nothing in
this world can satisfy, the only logical explanation is that I was
made for another world."* We're homesick for heaven. A place
where lives are no longer broken, where wars don't exist, and
right triumphs every time. A place where our hurting hearts
are healed and love reigns supreme. This wish our hearts make
isn't an illusion, but a promise—a hope worth holding on to in
the darkness. God's eternal kingdom is not a fairy tale, it awaits
us at the end of this rugged trek through life.

. .

*Father, I believe that someday I will be
where You are. I will see Your face. Amen.*

*C. S. Lewis, *The Complete C. S. Lewis Signature Classics* (San Francisco:
HarperSanFrancisco, 2002), 114.

PERFECTLY CONTENT

*But godliness with contentment is great
gain. For we brought nothing into the world,
and we can take nothing out of it. But if we have
food and clothing, we will be content with that.*

1 TIMOTHY 6:6–8 NIV

We often tell ourselves that life would be grander if only we had more—more things, more time, more money, more popularity. If only we were smarter, thinner, prettier, life would be a breeze. But God has a different way of doing things, of more peace and less striving. Lay aside your grasping for more and simply be happy with the things you have. Don't know where to begin? Start small and thank God for every good thing you can see from where you're sitting.

*God, thank You for the blessing of the sun that
came up this morning. Thank You for another
day to bring glory to Your name. Amen.*

FACE-TO-FACE

*"Righteous Father, though the world does not know you,
I know you, and they know that you have sent me. I have
made you known to them, and will continue to make
you known in order that the love you have for me may
be in them and that I myself may be in them."*

JOHN 17:25–26 NIV

Jesus came to show us what God is like—to introduce us face-to-face to the God who is our Father and who loves us deeply. He longs to heal our hurts and be with us. Jesus lived out God's character right in front of us. And His greatest act of kindness was the sacrifice of Jesus to pay for our sins. Now that you've met Him, are you living out His love to others?

* * *

*Father, thank You for Jesus. Help me treat
everyone I encounter with Your love. Amen.*

UNBLEMISHED

*Once you were alienated from God and were
enemies in your minds because of your evil behavior.
But now he has reconciled you by Christ's physical
body through death to present you holy in his sight,
without blemish and free from accusation.*
COLOSSIANS 1:21–22 NIV

Actions speak louder than words. We say that we're following
Jesus, but are we living our faith by choosing God's way over sin?
Of course we're all human, which means we all fail sometimes
or convince ourselves that what we're doing isn't really that
bad. Modern culture makes light of sin and labels it with less
offensive titles, like *little white lies* and *the right to choose*—but
ultimately any alternative to God leads only to death. Have you
continued to indulge bad habits or lack of self-control?

*Lord, forgive me for allowing my sinful
impulses to control me. Give me strength
and courage to choose right over wrong. Amen.*

HOLY, HOLY, HOLY

"Holy, holy, holy is the LORD Almighty;
the whole earth is full of his glory."
ISAIAH 6:3 NIV

Holy, holy, holy! Lord God Almighty!
Early in the morning our song shall rise to Thee.
Holy, holy, holy! Merciful and mighty!
God in three Persons, blessed Trinity! . . .
Holy, holy, holy! Though the darkness hide Thee,
Though the eye of sinful man Thy glory may not see;
Only Thou art holy; there is none beside Thee
Perfect in pow'r, in love, in purity.

Regardless of your music preference, the words to many great
hymns speak scriptural truths. "Holy, Holy, Holy" was written
by English bishop Reginald Heber to teach the perplexing yet
wonderful truth of the Trinity. Try worshipping through the
words of this hymn today.

* *

Lord God Almighty! There is none beside You. You are
perfect in all Your ways, holy in all You do! Amen.

DESPERATE MEASURES

Lord, in my place of weakness and need, won't you
turn your heart toward me and hurry to help me?
For you are my Savior, and I'm always in your thoughts.
So don't delay to deliver me now, for you are my God.

PSALM 70:5 TPT

Our fears often torment our minds. What if I lose my job and can't afford to survive? What if I get sick and can't care for my children? Maybe you spend anxious hours pondering contingency plans for catastrophes that haven't happened, or perhaps you're living in the midst of tragedy and heartbreak. Desperation is never a good feeling. Job was assaulted with one agonizing loss after another, but his faith in God's love and goodness never wavered. And God is your help too.

* *

Father, when I need You, hurry to help me. Give me
courage and faith that You are mighty to save. Amen.

REALITY CHECK

*"I am Yahweh, Creator of all. I alone stretched
out the canvas of the cosmos. I who shaped
the earth needed no one's help."*
ISAIAH 44:24 TPT

Raise your hand if you're an obsessed-with-every-detail perfectionist. If people are staring, I apologize. Maybe you're not a perfectionist at all, but you probably know one. Perfectionism is a mind plague that, if left unchecked, can convince us that we can handle God's job better than He can. That's when we need a reality check—He is God and we are not. Details are not bad. God blesses some people with the gift of organization, but don't get caught up in thinking that God needs us to whip all the pieces in place for His plan to succeed. Take a rest from your obsession. God's got this.

* *

*Lord God, You are the all-powerful God of
the universe. Increase my trust in You. Amen.*

DEFINED BY JESUS

I have been crucified with Christ and I no longer live,
but Christ lives in me. The life I now live in the body, I live by
faith in the Son of God, who loved me and gave himself for me.
GALATIANS 2:20 NIV

What defines you? Usually when someone asks about us, we answer with what we do. "I'm a teacher." "I'm a mom." But is this the true essence of who you are? The apostle Paul wrote that "you died, and your life is now hidden with Christ in God" (Colossians 3:3 NIV). Would *Christlike* be the first adjective that people use for you? Too often we waste a lot of effort trying to "find ourselves," but there's only Jesus. How can you be defined by Jesus today?

. .

Father, keep me from finding my sense of worth
in my accomplishments. My true identity is
found only in Jesus' work on the cross. Amen.

JOYFUL HOPE

Why spend money on what is not bread, and your labor on what does not satisfy? Listen, listen to me, and eat what is good, and you will delight in the richest of fare.
ISAIAH 55:2 NIV

Christmas has always been my mother's favorite holiday. Her joy is infectious, and her giddiness childlike. She gives great attention to every detail in preparing for this special day—the most delicious food, ribbon-embellished packages stacked artfully beneath a glowing tree, family gatherings, and smiles. The promise of good things at Christmas brings joyful expectation. How would it affect our lives if we brought this same insatiable delight into every day as we look with joyful hope toward eternity? Today, allow your thrilling hope of heaven propel you to drop any worthless things you've been pursuing.

* * *

Father, what dissatisfying things am I using to find happiness? Fill me with the joy of hope! Amen.

WRITTEN ON YOUR HEART

*"This is the covenant I will make with the people of
Israel after that time," declares the LORD. "I will put
my law in their minds and write it on their hearts.
I will be their God, and they will be my people."*
<small>JEREMIAH 31:33 NIV</small>

This new covenant begins with Jesus. Before Him, God's laws
were written on stone tablets and scrolls, but through His
Son's sacrifice His ways are now etched into the hearts of all
believers by the Holy Spirit. And our loving Father knows that
the things that hold our attention and affections lie close to
our hearts. As Matthew Henry wrote in his commentary, we
should pray "that our duty may be done conscientiously and
with delight." And with this promise comes relationship—He
will be our all-sufficient God.

* *

*Lord, strengthen my desire and my
delight in obeying You. Amen.*

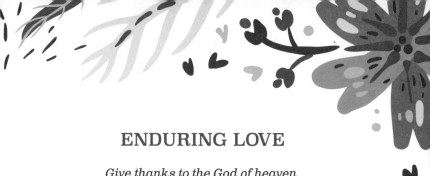

ENDURING LOVE

Give thanks to the God of heaven,
for his steadfast love endures forever.
PSALM 136:26 ESV

The steadfast love of God endures forever—marinate your mind in this truth for a moment. God's love for you is unfaltering, dear one. He isn't a fair-weather friend. No, His love isn't dependent on our actions. Thank goodness, because my measure would have run out long ago! His love stands forever. It's been tried and can endure anything. No matter what you've done or what has been done to you, whether you've suffered or caused suffering for others, God loves you. "God shows his love for us in that while we were still sinners, Christ died for us" (Romans 5:8 ESV). Allow God's love to permeate your mind and direct your actions.

* * *

Father, Your Word says that if I know You I will love others.
Teach me to love as unconditionally as You do. Amen.

115

WAIT FOR IT

But they who wait for the LORD shall renew their strength;
they shall mount up with wings like eagles; they shall
run and not be weary; they shall walk and not faint.
ISAIAH 40:31 ESV

Waiting is tough. God promised the Israelites a new homeland when they fled Egypt, but not right away. "So the land will not become a waste, and the animals of the field become too many for you. I will drive them out a few at a time, until you become many and take the land for your own" (Exodus 23:29–30 NLV). For our own good, God doesn't give us what we're not ready to handle. We must first learn obedience so we can avoid unwanted side effects that come from impatience and poor prep work— like being overrun by wild animals!

- -

Father, teach me to wait and grow in faith while
trusting You to bring Your plans to fruition. Amen.

FINDING TRUTH

"I the LORD speak the truth;
I declare what is right."
ISAIAH 45:19 ESV

God created every square inch of this universe, and He also equipped us with the tools we need to identify what is truth. We can experience truth through our senses, we can use the minds He gave us to reason, and we can learn from others who know truth. But some truths can be revealed to us only by God. And He never lies—it's not part of His character (1 Samuel 15:29). Examine the messages behind the words and images you encounter today. Ask yourself if the ideas being communicated are true, half true, or total falsehoods.

. .

Father, give me the wisdom through Your Word to identify
truth in this world so I'm not led astray by lies. Thank You
for always telling me the truth. In the midst of confusion
or hurt, I can trust You to tell me the truth. Amen.

MORE OF HIM

"What good will it be for someone to gain the whole world, yet forfeit their soul? Or what can anyone give in exchange for their soul?"
MATTHEW 16:26 NIV

It seems there's never enough money to satisfy our desires. If we get a raise or an unexpected bonus, we already have plans for the money and what we would do with even more—luxurious vacations, bigger homes, expensive shoes. Our desires can really run wild. But Jesus says that no matter how much stuff we can afford, or wish we could, He is the most important. Today when you talk to God in prayer, instead of asking Him for things you wish you had, ask for more of Jesus—more talks with Him, more prayer, more time in scripture.

. .

Father, I need more of You in my life. Give me more love, patience, understanding, and forgiveness for others. Amen.

HE IS MY STRENGTH

But he said to me, "My grace is sufficient for you,
for my power is made perfect in weakness."
Therefore I will boast all the more gladly about my
weaknesses, so that Christ's power may rest on me.
2 CORINTHIANS 12:9 NIV

Everyone has days when their strength doesn't seem sufficient to stretch to evening—when pulling the covers back over your head is an enticing thought. Impatience and snappish words come to the fore when work is overwhelming, the kids misbehave, the laundry forms mountains, and everyone's hungry. I know that I can't deal with all this alone. But through Christ I can! He is mighty when I feel like I might break. He has chosen you to be His instrument. Trust Him, and He'll be strong for you.

· ·

Lord, thank You for being strong for me. I don't have to do it
alone or hold everything together. That's Your job. Amen.

HEART AND MIND

Men cannot say they do not know about God.
From the beginning of the world, men could see what
God is like through the things He has made. This shows
His power that lasts forever. It shows that He is God.
ROMANS 1:20 NLV

Today many argue that faith in our Creator God is in conflict with the natural world around us. But astronomer, physicist, and engineer Galileo Galilei believed God gave us our minds to explore the world. He said, "The Bible shows the way to go to heaven, not the way the heavens go." We're free to pursue God's truth with both our heart and mind. But engage those who don't share your faith with humility. After all, the Bible is not a technical manual but instead a story of God's interaction with humans that points us to Christ. Love above all things.

. .

Creator God, give me humility and understanding
so that others may be drawn to Jesus. Amen.

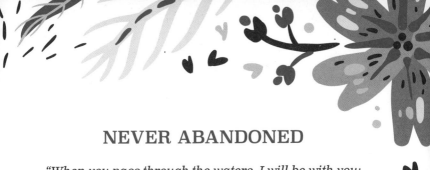

NEVER ABANDONED

"When you pass through the waters, I will be with you;
and when you pass through the rivers, they will not sweep
over you. When you walk through the fire, you will not be
burned; the flames will not set you ablaze. For I am the
LORD your God, the Holy One of Israel, your Savior."
ISAIAH 43:2–3 NIV

It's tempting to doubt God's love for us when we're suffering.
The enemy whispers that if God really cared about us, He'd
wipe away every trouble. But that isn't what scripture says.
Jesus said that in this world we would definitely have trouble,
but we need not worry, because He has overcome the world
(John 16:33). Read slowly through this scripture from Isaiah
and sit with the knowledge that when you experience hard
times, He is with you.

Father, keep my thoughts focused on the truth of Your
presence with me even through the fire. Amen.

IN HIS IMAGE

So God created man in his own image, in the image of
God he created him; male and female he created them.

GENESIS 1:27 ESV

God created you in His image. And while this doesn't mean that
we don't sin or that we're exactly like God, it does mean that we
can see a reflection of Him in ourselves. You can see aspects
of God in the way you're put together. You can catch glimpses
of Him in your creativity, your appreciation for beauty, your
compassion, or love of justice. So don't downplay your worth
or disregard the talents God has given you. Instead, ask Him
how you can use those things to bring glory to His name. Do
others see Jesus superimposed over your life?

Father, help me to be a reflection of You to others. Make my
life a message and a masterpiece of who You are. Amen.

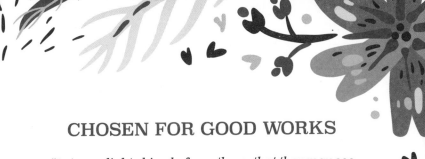

CHOSEN FOR GOOD WORKS

"Let your light shine before others, that they may see your good deeds and glorify your Father in heaven."
MATTHEW 5:16 NIV

A Catholic priest named Father Damien traveled from Belgium to Hawaii in 1873 to live at the Molokai leper colony. He was moved by compassion to help the suffering when no one else would. He worked to build houses and a church. He nursed those who were very sick and taught the people about the Bible. Eventually Father Damien also contracted leprosy and died after sixteen years on Molokai. By the time of his death, other missionaries had come to help. Father Damien glorified God by giving His life in service to others. Are you known for your good works? What can you do for others that will lead them to glorify God?

Father, let my good works be a light to others in dark places. Show me who needs my help today. Amen.

BE KIND

The fruit of the Spirit is. . .kindness.
GALATIANS 5:22 NIV

Kindness often gets a bad rap. We think those who turn the other cheek are weak. But scripture tells us that God is kind—and He most certainly is not weak. Sometimes we can be a little too much like the Israelites, who had short memories for "[God's] many kindnesses" (Psalm 106:7 NIV). But God is kind, and as His children we should be too. Colossians tells us to "clothe yourselves with. . .kindness" (Colossians 3:12 NIV). Next time you encounter a rude coworker or your children trample your last nerve, remember to be kind.

* *

Father, sometimes I struggle to be kind. I get impatient and tired and don't feel like being kind. But You have shown me kindness upon kindness that I don't deserve. Help me to go and do likewise. Amen.

SLIPPERY SLOPE OF SIN

*But each person is tempted when they are dragged
away by their own evil desire and enticed. Then, after
desire has conceived, it gives birth to sin; and sin,
when it is full-grown, gives birth to death.*

JAMES 1:14–15 NIV

Sin usually starts with a small concession. So scripture wisely
tells us to take captive every thought and make it obedient to
Christ. Joseph's brothers didn't decide to kill him out of the
blue. When they indulged the sins of anger and jealousy, their
hatred bloomed into a murder plot. Grievous sin always begins
with one little thing—an unforgiving thought, a little white lie.
Have you ever let angry words fly and later regretted it? Do you
have a "small" sin that you need to repent of before it grows
unchecked into a bigger problem?

*Heavenly Father, search my heart and show me anything in
my heart and actions that goes against Your ways. Amen.*

CONVERSATIONS WITH GOD

Make your life a prayer.
1 THESSALONIANS 5:17 TPT

Imagine the worries that would fall away if you were to live your whole life in conversation with God. The more time you spend talking to God about His desires for your life and telling Him all the amazing things you've noticed about Him, the more you will also begin to notice all the ways He answers you, gives you direction in difficult situations, or resolves a problem you had no idea how to solve. And when you're upset, there's no one better to hear your complaints. Because not only will He understand, but He'll also gently confront you with truth when you need redirected. How can you live in prayer today?

Father, I want to wake up praising You for the day You've given me and fall asleep telling You about my day. And every moment in between I want to talk to You. In Jesus' name, amen.

UNSTOPPABLE

If God is for us, who can be against us?
ROMANS 8:31 ESV

It's been said that one sure way to get a chuckle from our heavenly Father is to tell Him our plans—because too often we cook them up without consulting Him. So it's no surprise that we sometimes fail in spectacular fashion. We fall. We lose. We crash and burn everything we've built, and, in the process, maybe even those we love. But beloved, don't kick the ashes in defeat. Sometimes the aftermath of defeat teaches us to search out God's best for us. This verse doesn't mean we'll never fail or struggle. And it certainly doesn't mean we'll accomplish every half-baked idea that turns our head. Remember that when You're following God, nothing can stand in the way of His plans.

. .

Father, show me the plans You have for me,
plans of hope and a future. Amen.

MY WEAKNESS, HIS POWER

*"Please, Lord, how can I save Israel? Behold,
my clan is the weakest in Manasseh, and I
am the least in my father's house."*
JUDGES 6:15 ESV

David didn't walk out to meet Goliath because he was a mighty warrior, and Gideon didn't defeat the Midianites because he was a shrewd general. They won great victories because they trusted God when He said He was with them. Neither do you need to have significant resources or impressive skills to be used for God's purpose. God delights in working miracles through our flawed efforts to serve Him. Take a moment today and consider the interests or skills in your life that you consider small. Ask God how He could use them significantly in His kingdom.

* *

*God, I often feel small and unimportant like Gideon,
but I want to trust that You can use whatever
I have to do big things. Amen.*

DON'T TURN AWAY

"I myself said, 'How gladly would I treat you like my children and give you a pleasant land, the most beautiful inheritance of any nation.' I thought you would call me 'Father' and not turn away from following me."
JEREMIAH 3:19 NIV

Toddlers have little affection for hearing the word *no*. And they often let their wishes be known in spectacular tantrum fashion. As we grow in maturity we learn to deal with disappointment more gracefully, or so we hope. But we still don't enjoy having our wishes denied, even by our heavenly Father. Do you balk and pout when God doesn't give you the answer you want? Imagine your human understanding compared to the incalculable wisdom and love of your heavenly Father. Remembering that He sees the eternal ramifications can sweeten the bitter pill of "no."

. .

Father, help me to follow You no matter what.
To trust Your sweeping perspective. Amen.

JOYFUL SERVICE

*"Whoever wants to become great
among you must be your servant."*
MATTHEW 20:26 NIV

Let's face it. We all want the cushy job with all the perks—the vacation home, the boat, the luxury of relaxation. It all sounds so good, and it's oh-so-easy to think only of our own fun and comfort. But Jesus doesn't measure life's success with our yardstick. Instead, He lived a life not of indulgence but of service. "Whoever wants to be first must be slave of all. For even the Son of Man did not come to be served, but to serve" (Mark 10:43–45 NIV). Do you know anyone who could use rescue—a kind word or a little help? How can you serve them humbly in love today?

* *

*Father, show me the needs of a hurting world
around me. I don't want to ignore the pain of
others while I enjoy the comforts of life. Amen.*

CLEAN HEARTS

"You are like whitewashed tombs, which look beautiful on the outside but on the inside are full of the bones of the dead and everything unclean."
MATTHEW 23:27 NIV

Jesus had harsh words for hypocrites who put all their effort into looking good but ignored the decay inside. Scripture says, "Come close to God and He will come close to you. Wash your hands, you sinners. Clean up your hearts, you who want to follow the sinful ways of the world and God at the same time" (James 4:8 NLV). We simply can't have it both ways. We can't live as the world does and follow Jesus' example at the same time. What parts of your life are you trying to live as the world instead of following Jesus?

Lord, keep me from spending all my time trying to look perfect for other people, but allowing jealousy, pride, and selfishness to fester in my heart. Amen.

INCOMPREHENSIBLE PEACE

*Do not be anxious about anything, but in every
situation, by prayer and petition, with thanksgiving,
present your requests to God. And the peace of God,
which transcends all understanding, will guard
your hearts and your minds in Christ Jesus.*
PHILIPPIANS 4:6–7 NIV

Peace is living out the fact that God is in control and that you belong to Him. The chaos and uncertainty of this world will test your trust in God. But if you own this scripture and live it, His peace will cocoon your mind and heart. In everything, trust Him. In every situation, pray. And peace beyond understanding will comfort you. You may not understand it, and the world will look at you and wonder how you could possibly be at peace. But your mind will rest easy.

*Father, I submit to Your control. No matter what
happens You are my God and I belong to You. Amen.*

DILIGENT OVERSEER

For we are God's handiwork, created in
Christ Jesus to do good works, which God
prepared in advance for us to do.
EPHESIANS 2:10 NIV

God has given us so many wonderful gifts. And everything we have—money, time, abilities—ultimately belongs to God. We're just overseers of His abundant wealth. Following Christ doesn't mean that we laze through life waiting for Jesus to return and take us on an eternal vacation. Instead, Jesus calls us to be about our Father's business, just as He was. How will Jesus find the resources He has entrusted to you when He returns? Will He find them wasted or neglected, or will He ecstatically discover that you've put them to good use for His glory?

. .

Father, show me the untapped resources I have at my
disposal and help me use them to honor You. When I
see You face-to-face, I long to hear, "Well done." Amen.

MADE RIGHT

*For all men have sinned and have missed
the shining-greatness of God. Anyone can
be made right with God by the free gift of His
loving-favor. It is Jesus Christ Who bought them
with His blood and made them free from their sins.*
ROMANS 3:23–24 NLV

We all mess up, sometimes worse than others. But the main point is not the degree of our sin, but rather the fact that we do sin—all of us. And while we can't get a do-over, friend, there's hope. Jesus lived a perfect life and then died in your place—and mine. We're free. Forgiven. When we confess our sins and accept His forgiveness, we step into the boundless grace of our great and loving God.

. .

*Father, I'm so sorry for the wrong I've done against
You. The depth of Your love takes my breath away—
that You would die for me. Amen.*

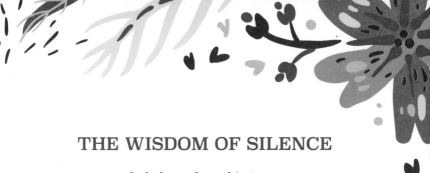

THE WISDOM OF SILENCE

A fool always loses his temper,
but a wise man keeps quiet.
PROVERBS 29:11 NLV

We all get upset sometimes. But it's how you react that will showcase your wisdom—or prove you a fool. Our heavenly Father says that wisdom is using your self-control, even when you're angry. Keeping a tight rein on your control is even more important when you're upset. After all, it's not much of a show of control when you have nothing to be aggravated about. Too often anger drives us into sin—yelling, slamming doors, using hurtful words, and engaging in various kinds of abuse. The next time you feel your ire rising, stop and pray. Ask God to bolster your self-control.

Father, give me strength. Keep me from saying
or doing hurtful things in anger. Amen.

HOPE IN HIM

Why, my soul, are you downcast? Why so disturbed
within me? Put your hope in God, for I will yet
praise him, my Savior and my God.
PSALM 42:5 NIV

Does your future look brighter if you have a hefty bank account
or a prestigious position, or if you do loads of charity work?
Or maybe hope for the future sparks with a new relationship.
When things are going well, these things can seem to sustain
our good mood, but do they offer hope when friends betray you,
or your health fails, or your loved ones die? Don't be fooled into
propping your future against failing supports. Put your hope
in God—the only One who will never fail you—and see how He
can transform certain despair into hope of a good future.

Father, I have no cause to be disturbed when
I put my hope in You. When I'm feeling low,
remind me to faithfully trust in Your plan. Amen.

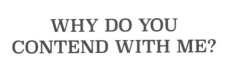

WHY DO YOU CONTEND WITH ME?

"I will say to God, 'Do not condemn me;
let me know why You contend with me.'"

JOB 10:2 NASB

Tough love—sometimes as parents we use hard measures against our children to equip them for the future, to teach them a better way. It doesn't mean we're unsympathetic or unfeeling. On the contrary, our great love compels us to prepare them fully for the future. And if we can employ such designs with our children, how much more can God's great love move Him to teach us maturity. As believers we sometimes cry out with Job in the midst of struggles, "Why are You striving against me?" Whether you've been through something or are going through something now, how is God using hard things to hone your faith?

Heavenly Father, I know You love me. Teach me
to grow stronger through my struggles. Amen.

137

TRAINING GROUND OF TRIALS

He trains my hands for battle,
so that my arms can bend a bow of bronze.
PSALM 18:34 NASB

The grueling exercises of boot camp churn out mature, highly disciplined, and fully capable soldiers. Charles Spurgeon wrote, "See you not, then, that God may take away your comforts and your privileges to make you the better Christians? Why, the Lord always trains his soldiers, not by letting them lie on feather beds, but by turning them out and using them to forced marches and hard service He makes them ford through streams, and swim through rivers, and climb mountains, and walk many a long march with heavy knapsacks of sorrow on their backs.... Warriors are really educated by the smell of powder, in the midst of whizzing bullets, and roaring cannonades—not in soft and peaceful times."

. .

Heavenly Father, hone me into a mature,
disciplined, and capable warrior. Amen.

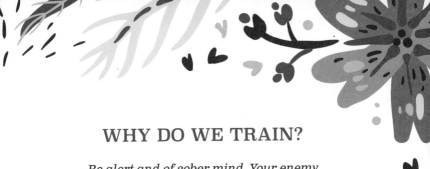

WHY DO WE TRAIN?

*Be alert and of sober mind. Your enemy
the devil prowls around like a roaring
lion looking for someone to devour.*
1 PETER 5:8 NIV

Maybe you have zero desire to bend a bow of bronze like David, but God has your protection and victory in mind when He hones your spiritual muscles by allowing you to struggle. If you want to build muscle, you pump some iron. Likewise spiritual strength and understanding grow by grappling with God's truth. God knows these survival skills are vital to your faith because the enemy lurks in the darkness. And he wants to take you down. What attacks are devouring you—doubt, fear, discontent, unforgiveness, anger? Pull out your Bible and find scripture you can use to fight back.

*Father, keep me alert to Satan's attacks. Prepare my mind
with Your words of truth and give me victory. Amen.*

IMMANUEL

"The virgin will conceive and give birth to a son,
and they will call him Immanuel"
(which means "God with us").

MATTHEW 1:23 NIV

The baby born long ago in a stable, the Son of the living God, is our Immanuel, God with us. God literally took human form and walked among us, and then He sent us the Holy Spirit so we'd never be without Him. Peace is not the absence of trouble but the presence of God in the midst of trouble. When you face a raging storm, or maybe you're already hit with gale-force winds—whether its difficult relationships, job loss, health problems, anxiety—God is with you. The source of your peace will never leave you.

Immanuel, thank You for the comfort and peace of mind I have in knowing that You are here with me. Amen.

LETTING GO

My beloved brothers and sisters. Now everyone must be quick to hear, slow to speak, and slow to anger; for a man's anger does not bring about the righteousness of God.
JAMES 1:19–20 NASB

Your friend's insensitive words play on a loop in your brain long after the party has ended. By the next morning, not only are you cranky from sleep deprivation but you're also ready to hand her a piece of your mind. Maybe what she said wasn't true, or maybe it was; either way it hurt. But holding on to your anger damages you more than her piercing words. Forgive, move on, overlook this offense, because your anger won't lead you to love like Jesus. And you've probably said a few hurtful things you'd like overlooked too.

Father, give me a readily forgiving heart. Help me to stop angry thoughts before they grow. Amen.

A GOOD FRIEND

A friend loves at all times, and a
brother is born for a time of adversity.
PROVERBS 17:17 NIV

Sometimes we feel less than loving toward our friends. Maybe they've hurt our feelings or we're too wrapped up in our own busyness to listen to their troubles. Good friends are hard to find, and being a good friend to others can be equally difficult. But sometimes we need help through the struggles of life—and that's where friends come in. Take a moment and think of a friend you have who is trustworthy, kind, and dependable, and thank God for putting her in your life. And if you can't bring to mind a single person, ask God for a friend. He'd love to oblige.

. .

Father, thank You for giving me friends that I can count on.
Help me to be a good friend in return. Show me how I
can help and encourage them in hard times. Amen.

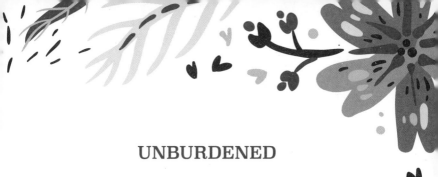

UNBURDENED

*"Be careful, or your hearts will be weighed
down with...the anxieties of life."*
LUKE 21:34 NIV

Have you ever felt overwhelmed? Of course you have, friend, because at some point in this messy journey we all do. Jesus doesn't expect us not to experience the stresses of life. He knows that our enemy prowls around like a hungry lion looking for ways to devour our peace. No, having problems isn't really our issue when we're overtaken by anxiety. It's how we react. Some of us get snappy, some of us cry, and some of us hide. Jesus longs for you to come and sit at His feet, and lay down those heavy burdens of life, knowing that He can provide.

. .

*Jesus, help me trust You to provide in
every circumstance. You have the answers,
wisdom, and resources I need. Amen.*

THE MEANING OF LOVE

You obey the whole Law when you do this one thing,
"Love your neighbor as you love yourself."
GALATIANS 5:14 NLV

In today's world *love* is a pretty casual word. We love our favorite jeans and we love our children. We love ice cream and we love God. Love often means something that brings pleasure to our lives. But God's picture of love is not self-indulgent. God-love denies itself and gives unconditionally without expecting something in return. In 1 Corinthians 13:4–7, scripture teaches us how to recognize love: it is patient, kind, not envious, boastful, or proud. It honors others, is not selfish or easily angered, and keeps no record of wrongs. It doesn't delight in evil, rejoices with the truth, protects, trusts, hopes, and perseveres. Are you ready to take up the challenge of loving others?

. .

Father, may my behavior toward others
reflect the perfect love You have for me. Amen.

BE STILL

"The LORD will fight for you;
you need only to be still."
EXODUS 14:14 NIV

Tragedy, death, betrayal, illness, addiction, failure, loss, poverty, abuse—life can wound us horribly. And we find it difficult to trust God when it seems as if He is not paying attention to the collapse of our world. But, friend, the thought that God can't, won't, or doesn't care to step into your circumstances is a poisonous lie of the enemy, put into your mind to weaken your faith. When all seems lost, trust. When hope fades, trust. Sometimes the hardest task is not what God asks you to do but what He asks you not to do. Don't trust in your own plans. The Lord will fight for you.

· ·

Father, I know that You love me beyond compare.
Sometimes I feel the need to fix things when I
really should be praying and trusting. Amen.

PARDONED!

Who is a God like you, who pardons sin?
Micah 7:18 niv

"Will you forgive me?" Never have any other words burgeoned with such tentative hope. We desire to have our shame wiped away and our wrongdoing passed over. One of the first things we're introduced to in the Bible is the shame and punishment linked to human sin. But oh, beloved daughter, this isn't the end of God's story. Hope pierces the darkness with scouring light because we serve a God who pardons sin. His grace covers our shame. Have you experienced the freeing soul-relief of forgiveness? It's yours for the asking. "If we confess our sins, he is faithful and just to forgive us our sins and to cleanse us from all unrighteousness" (1 John 1:9 esv).

* *

*Father, I know I've sinned. Please forgive me
and strengthen me to choose right. Joy washes
through me because of Your mercy. Amen.*

YOUR CHOICE

"Choose for yourselves this day whom you will serve....
But as for me and my household, we will serve the Lord."
Joshua 24:15 niv

We make a thousand choices every day. Most mean little in the long run, but the rest of our lives and even our eternities hinge on what we choose—who our friends are, what we do with our time and resources. What will we eat, watch on TV, or listen to? Will we use kind words or rude? Will we pray or read scripture today or choose a novel instead? Our character is built from the bricks of our everyday choices. Take a moment and inventory your choices this week. Who are you serving with the decisions you've made? Are you serving God with righteous living?

* *

Father, reveal the choices I'm making
that don't honor You. Amen.

HE HEARS MY VOICE!

I love the Lord, because He hears my voice and my prayers.
PSALM 116:1 NLV

Your friend's voice drones into the background of your thoughts, and you realize you missed half her story. We're not always the best listeners. But thankfully our heavenly Father doesn't suffer from our shortcoming. He is never distracted or uninterested in what we have to say to Him. He hears our prayers. In a world of lonely, disconnected people, we kindle a blaze of hope by sharing the news that there's no time or place that we cannot have a conversation with the great God who created us and loves us. It's beyond amazing that we have this kind of unlimited access to the living God.

. .

*God, I'm in awe that You, Creator of the universe,
listen to my problems and take the time to speak to
me. Thank You for Your boundless love for me. Amen.*

VICTORY OVER DEATH

You have been given a new birth. It was from a seed that cannot die. This new life is from the Word of God which lives forever. All people are like grass. Their greatness is like the flowers. The grass dries up and the flowers fall off. But the Word of the Lord will last forever.
1 PETER 1:23–25 NLV

Fatal car accidents, unexpected illnesses, tragic crimes—people are dying all around us. And to stave off panic over the transient nature of life, we numb ourselves to their passing. Scripture says that human lives wither like the grass, here one moment and gone the next—but remember God's promise! This world is just the prelude. Through Christ we are born from an eternal seed into new, everlasting life. If you fear death, accept His gift of eternal life. And if you already have, maybe you've lost sight of just how much God loves you.

God, I look forward to eternity with hopeful expectation. Amen.

FORGIVE

A man's understanding makes him slow to anger.
It is to his honor to forgive and forget a wrong done to him.
PROVERBS 19:11 NLV

Forgiveness can be hard work. When someone injures us, often anger floods in. We know scripture says to forgive, but we're suffering emotionally. In this moment be very careful not to let the enemy get the upper hand and convince you that you're justified in holding a grudge. The truth is that forgiveness doesn't mean that what was done against you was right or okay, but instead that you choose not to sin in your suffering. Jesus, who had far more right to feel justified, said, "Father, forgive them," as they nailed Him to the cross. Are you harboring any offenses today?

. .

Father, help me let go of grudges. I don't want to allow
bitterness and anger to twine roots into my soul. Amen.

ON THE RUN

Where can I go from your Spirit?
Where can I flee from your presence?
PSALM 139:7 NIV

Have you ever wanted to hide from your mistakes? When our anger gets the best of us and we snap at our children, when we shade the truth to look better for our friends, we feel the pinch of the Holy Spirit's chiding in our soul—and we sometimes make haste to head opposite of the Father. But sweet daughter, God already knows. There's nowhere we can run from Him and no hiding from His Spirit. But there's comfort here in this truth as well. No matter how far out of bounds we think we've strayed, the grace and love of the Father can catch us even there. Have you been afraid to face God in the aftermath of your failure? Rest assured, His grace is sufficient.

- -

Father, I'm sorry for hiding from You.
Please forgive me. Amen.

HEALING JOY

A joyful heart is good medicine,
but a crushed spirit dries up the bones.
PROVERBS 17:22 ESV

Joy in your heart can change your perspective of even desperate circumstances. Paul and Silas showed us that even after being beaten and thrown in prison, they could still choose joy in their salvation and even sing praises to God through bruised and broken bodies. Your attitude can really influence your outlook. Next time you're feeling battered by life, choose joy anyway and see how it brightens your spirits. We have a heavenly Father who adores us and eternity in heaven awaiting! The world is watching. And just as Paul and Silas led the jailer and his household to Jesus, your joy can bring others to Christ.

* *

Father, help me to choose joy instead of depression
today. I don't want to wallow in a negative perspective.
I have a song in my heart because I trust in You. Amen.

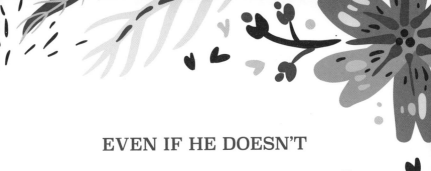

EVEN IF HE DOESN'T

"The God we serve is able to deliver us from it, and he will deliver us from Your Majesty's hand. But even if he does not, we want you to know, Your Majesty, that we will not serve your gods or worship the image of gold you have set up."
DANIEL 3:17–18 NIV

When life goes horribly wrong, we cry out for escape. Our first thought, and often desperate prayer, is "Please, get me out of here!" Shadrach, Meshach, and Abednego didn't back down from their faith. They braved the fire—and walked out of the furnace without a hint of smoke on their clothes. But they were prepared to trust God. They knew He *could* deliver them even if He didn't. What potential setbacks do you face? Are you willing to trust God even if things don't come out as you planned?

- -

Father, I trust that Your plan is good.
My faith is in You no matter what. Amen.

A FATHER'S BROKEN HEART

Never grieve the Spirit of God or take
for granted his holy influence in your life.
EPHESIANS 4:30 TPT

Our children can pierce our hearts with pain. With the power of a few wrong choices, they bring us to our knees. And hopefully we're praying from this position. But this heartbreak is a mere reflection of the sorrow we bring to God's heart with the sin we often embrace. Each moment of gossip, each angry word or selfish act—each sin is a turn of the knife. Just as we want better for our offspring than a lifetime of regret and poor choices that lead to endless suffering, God wants more for us too. He wants us to run and not grow weary. He wants us to soar. How have your actions grieved your Father recently?

. .

Lord, I'm so sorry I've caused You pain. Show me
how I'm hurting You. Help me to choose right. Amen.

GROW

Let us move beyond the elementary teachings
about Christ and be taken forward to maturity.
<small>HEBREWS 6:1 NIV</small>

Growing pains have earned their name for a reason. Change can hurt. Our kids labor through years of instruction in their schooling. As their brains develop, they can understand more complex ideas and begin to practice problem-solving and decision-making skills. The writer of Hebrews warns that as followers of Christ we can't stay in elementary school either. We need to move forward into maturity. A fully developed love that acts as Jesus would and a mature recognition of the evil we battle should blossom as we grow up in our faith. Study the Bible and pray about the areas in your life where your growth has stagnated.

- -

Father, give me strength to choose right.
Fill me with a desire to know more of
Your ways as I grow in maturity. Amen.

OTHERS FIRST

To the humble he gives favor.
PROVERBS 3:34 ESV

Is the word *humble* stamped across the image of a doormat in your mind—something others scrape their dirt on? Mostly we'd rather be enthralled with our own importance. As women we find countless ways to compare ourselves to others. We value ourselves in pounds on a scale and carats in our diamonds, and even the success of our children. Our vanity is boundless as we compete for first place in trivial things. The apostle Paul urged believers to "do nothing out of selfish ambition or vain conceit. Rather, in humility value others above yourselves" (Philippians 2:3 NIV). Value others above yourself—just like Jesus did. Who have you been putting first?

· ·

*Father, teach me to give more value to others.
"Me first" is an easy motto to live by. Teach me
to consider the needs of others. Amen.*

A PLACE FOR YOU

"Do not let your hearts be troubled. You believe in God;
believe also in me. My Father's house has many rooms;
if that were not so, would I have told you that I am going
there to prepare a place for you? And if I go and prepare
a place for you, I will come back and take you to be
with me that you also may be where I am."

JOHN 14:1–3 NIV

Life can be so disappointing, sometimes devastatingly so.
We fail, we fall, and we fumble opportunities. We lose jobs,
loved ones, and sometimes our minds. But Jesus left us with
a powerful promise. He is coming back for us! We will spend
eternity where sadness and sin no longer reign, where fear
and pain are forever conquered and goodbye is but a memory.

* *

Jesus, You're preparing a better home for me—
the one I've been longing for! Amen.

NUMBER YOUR DAYS

*Help us to remember that our days are numbered, and help
us to interpret our lives correctly. Set your wisdom deeply
in our hearts so that we may accept your correction.*

PSALM 90:12 TPT

As we age, time seems to pass faster and faster. Some days I feel
as if I'm watching it flash by outside the window of the bullet
train. I'd love to hop off the rails and savor every moment, but
the days blur by anyway. Maybe this perception of speeding time
as we age is actually a gift from God. The faster time passes
the more we see it as a precious commodity. Fleeting things
of earth fade. Treasure this day God has given you. Ask Him
what He'd like you to do today.

*Father, teach me to number my days. Each day is
a gift I can give back to You by living holy. Amen.*

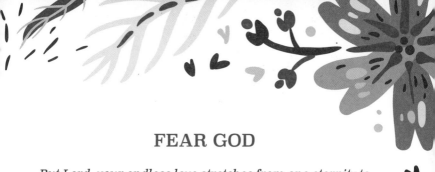

FEAR GOD

But Lord, your endless love stretches from one eternity to the other, unbroken and unrelenting toward those who fear you and those who bow facedown in awe before you.

Psalm 103:17 TPT

Sometimes we humans get a little too caught up in our own importance. We forget the magnitude of who God is—the all-powerful Creator of every grain of sand on every ocean-kissed beach and sun-scorched desert. Magnificent Maker of billions of stars that sparkle like gems against the backdrop of the universe. Master of waves and weather. Artisan of every atom, Originator of tiny organisms, Shaper of cells, nothing is too hard for Him or lies outside His reach. This great God cares for You with an unquenchable love. Fearing Him means never forgetting that He is God.

God, You are holy and awesome. Worthy of my respect and obedience. Thank You for Your love and faithfulness. Amen.

THE PEACE HE GIVES

"I will ask the Father, and he will give you another advocate
to help you and be with you forever—the Spirit of truth. The
world cannot accept him, because it neither sees him nor
knows him. But you know him, for he lives with you and will
be in you. I will not leave you as orphans; I will come to you."

<small>JOHN 14:16–18 NIV</small>

When Jesus left the earth, He asked the Father to send us an incredible gift—our Advocate, Helper, Teacher, Guide, and Comforter—the blessed Holy Spirit who give us peace. "Peace I leave with you; my peace I give you. I do not give to you as the world gives. Do not let your hearts be troubled and do not be afraid" (John 14:27 NIV). The Spirit of God dwells in us.

* * *

Father, thank You for the presence, power,
and peace of the Holy Spirit in my life. Amen.

LOVE WINS!

Love never fails.
1 CORINTHIANS 13:8 NIV

It's nearly impossible to find a sure thing. We put our trust in friends who walk away, jobs that disappoint, and possessions that rust and break. But scripture tells of one sure thing that never fails—love. You might say that love has failed you through divorce or betrayal. And it's true: the "love" of humans will falter. But there's One whose love is patient and kind, never jealous or proud. It's never self-seeking or easily angered. His love doesn't keep a record of your offenses. It always protects, trusts, and hopes, and forever will persevere. The love of God never fails (1 Corinthians 13:4–8). He didn't have to give up His Son to pull us back from death's cold grip, but He did. Love compelled Him. What will your love compel you to do today?

. .

*Father, Your love triumphs! Quicken this
same love in my heart. Amen.*

ADOPTED

The Spirit himself testifies with our spirit that we are God's children. Now if we are children, then we are heirs—heirs of God and co-heirs with Christ, if indeed we share in his sufferings in order that we may also share in his glory.

ROMANS 8:16–17 NIV

Wealthy citizens in first-century Rome who lacked an heir would often adopt a young slave boy as their son. Slaves often performed hard labor and suffered abuse. Their every moment was controlled by the needs of their master. But once they were adopted, slaves began a brand-new life as their father's heir. The ties to their old family were severed and their old debts forgiven. We too have been redeemed from our old lives of sin. The ties to darkness and death have been severed. We're heirs with Christ.

* * *

Father, help me rejoice even in the sufferings of this life, because the glory of heaven far outweighs the pains I have now! Amen.

PRESS ON

Not that I have already obtained this or am already perfect, but I press on to make it my own, because Christ Jesus has made me his own.
<small>PHILIPPIANS 3:12 ESV</small>

Press on. These words conjure up the image of a difficult journey, a struggle to survive harsh conditions. But they also offer up the hope of a better destination. "Press on" seems to say that there's something promising up ahead, something worthy of the hardship, something worth striving for. We haven't reached perfection, nor will we in this world, but the apostle Paul urges, "Press on." When trials test your faith, choose trust. When illness threatens death, choose His life. When despair darkens your door, choose hope. When hate haunts your thoughts, choose love. Press on to His kingdom, beloved!

. .

Father, You are my strength when I am weak.
Fill me with the will to press on,
right into Your arms. Amen.

PATTERN FOR YOUR LIFE

*I want you to pattern your lives after me, just as I
pattern mine after Christ. And I give you full credit
for always keeping me in mind as you follow carefully
the substance of my instructions that I've taught you.*

1 Corinthians 11:1–2 tpt

Have you noticed that kids do as they see instead of as they're told? Our actions are much more powerful teachers than our words. Can you offer up this same advice to the believers around you? Are you confident enough in your walk to hold it up as an example to follow? Whether we say the words or not, our children and faith children are watching to see what we'll do. Our actions don't just affect us; they affect all those we are teaching by example.

*Lord, make me a worthy example. I know that
I'm not perfect, but teach me to pattern
my life after Christ. Amen.*

FIXER-UPPER

We are being transfigured into his very image as we move
from one brighter level of glory to another. And this glorious
transfiguration comes from the Lord, who is the Spirit.
2 CORINTHIANS 3:18 TPT

Our first house was a gem—but in the rough for sure. The stench cut you down as you crossed the threshold, and neighbors said the place needed a match not a makeover. But we gutted her practically to the studs and started over. Before Jesus, our lives are a lot like that house—smelly, dirty, broken down, hopeless. But Jesus—He sees the promise of good bones, just like we did in that house. He sees us not for what we are but for what we could be with Him. His Holy Spirit can refurbish our dirty dysfunction and transform us into His ever-increasing glory.

Father, thank You for remaking me in You. Amen.

WAIT IN HOPE

The eyes of the LORD are on those who fear him, on those
whose hope is in his unfailing love.... We wait in hope
for the LORD; he is our help and our shield.
PSALM 33:18, 20 NIV

When prosperity flows and you're whistling "Zip-a-Dee-Doo-Dah," it's simple to hope in God's love and trust His future for you, because that future seems pretty bright from where you're sitting. But God's unfailing love for us stretches farther than this earthly lifespan, as do His plans. We like comfort, so it is natural that we want help and a shield on our terms. But God may have your long-term good in mind instead of your immediate comfort. Remember that His love never fails, and He may be teaching you to wait in hope no matter what. Where is God saying "Wait" in your life?

Father, I put my hope in Your unfailing love,
not in circumstances. Amen.

UNOFFENDABLE

You are always and dearly loved by God! So robe yourself with virtues of God, since you have been divinely chosen to be holy. Be merciful as you endeavor to understand others, and be compassionate, showing kindness toward all. Be gentle and humble, unoffendable in your patience with others. Tolerate the weaknesses of those in the family of faith, forgiving one another in the same way you have been graciously forgiven by Jesus Christ. If you find fault with someone, release this same gift of forgiveness to them.
COLOSSIANS 3:12–13 TPT

Now that you belong to God, He wants you to live holy. But how can we robe ourselves with the virtues of God? That's a lofty goal, especially when grumbling is second nature. If you find fault with someone, remember that God has endless reasons to find fault with you too, but through Jesus this tremendous debt is forgiven. Knowing this should lighten your spirits!

- -

*God, make me unoffendable in
my patience. In Jesus' name, amen.*

CHOSEN FOR POWER

*"I promise you this—the Holy Spirit will come upon you,
and you will be seized with power. You will be my
messengers to Jerusalem, throughout Judea, the distant
provinces—even to the remotest places on earth!"*

ACTS 1:8 TPT

God doesn't make empty promises, and He never offers meaningless gifts. When Jesus left the earth after His resurrection, He promised the disciples that they wouldn't have to go it alone—and neither do you. When you're struggling to trust or exhaustion weights your limbs, when you just feel like you can't, there's hope—because *you* don't have to handle it. Jesus will. He promises that through the Holy Spirit we can share in the power of God. The disciples were filled with power and traveled the known world spreading the Gospel. They showed heroic courage in the face of grave circumstances— through God's power.

* *

Lord, I need Your Spirit's power today. Amen.

SHE SPEAKS WISDOM

She opens her mouth in wisdom,
and the teaching of kindness is on her tongue.
PROVERBS 31:26 NASB

Have you ever lived to regret the deadly accuracy of your tongue? Undoing the damage once those lethal words are out can be impossible—like putting toothpaste back in the tube. But God has a different way, a path of holiness He wants us to rein in our words. Through the instruction of the Holy Spirit we can open our mouths, and instead of spewing poison, wisdom will flow out. We can offer encouragement and kindness through gentle and wise words to the people around us. God's wisdom teaches us that we don't always have to be first. Wisdom teaches us to love well.

* *

Father, fill my words with wisdom. Prevent unholy things
from leaving my mouth and injuring those around me.
Instead, give me wisdom to build and not destroy. Amen.

169

BELIEVE

*"Learn this well: Unless you dramatically change
your way of thinking and become teachable like
a little child, you will never be able to enter in."*
MATTHEW 18:3 TPT

Our little ones pray with childlike wonder. Everything seems possible because they frolic in a world of fairy tales and miracles unshaded by adult disappointment and devastation. But with God, believing that nothing is impossible doesn't have to fade with our childhood. Fully trusting Him isn't childish fancy. Take a moment and think about what's weighing on your mind—a broken relationship, a lost job, a difficult decision—and bring it to God with childlike faith that He is able to step into your circumstances with solutions you didn't think were possible, fully expecting His answer.

* *

*Father, I believe. Help me to pray as I did when I
was a child, fully believing that You are able. Amen.*

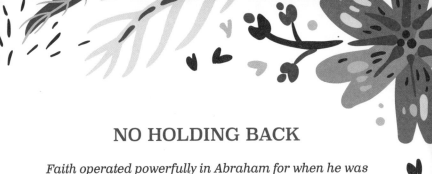

NO HOLDING BACK

Faith operated powerfully in Abraham for when he was put to the test he offered up Isaac. Even though he received God's promises of descendants, he was willing to offer up his only son! For God had promised, "Through your son Isaac your lineage will carry on your name." Abraham's faith made it logical to him that God could raise Isaac from the dead, and symbolically, that's exactly what happened.

HEBREWS 11:17–19 TPT

What do you hold close to your heart? Your children? Your money or position? Are you willing to trust God with it, to prove your faith? Tough question. Abraham had faith that God would keep His promise through Isaac, so he raised the knife over his beloved son and trusted God to provide. The great news is that God actually did what He asked of Abraham. He gave us Jesus.

. .

Father, search my heart and show me what I'm holding back from You, who gave everything for me. Amen.

HEAVENLY AMBITIONS

*"Those who have it very hard for doing right are happy,
because the holy nation of heaven is theirs."*
MATTHEW 5:10 NLV

Most of us learn from an early age that taking the easy road will usually result in more work later. Experience quickly educates us that there's only two ways to do something: right and again. But even when we choose the right way, trouble can pounce. Job definitely didn't anticipate the travesty that visited him. But he was certain of his Redeemer. And we can be too. Joy can well up in your soul when you keep an eternal focus. This life is short, but eternity is long. And a glorious home in heaven awaits after the troubles of this world are behind us.

. .

*Father, fill my heart with joy when I suffer for doing
the right thing. In the long run I will win! Amen.*

I WANT TO BE WITH YOU

*Make a clean heart in me, O God. Give me a new spirit
that will not be moved. Do not throw me away from where
You are. And do not take Your Holy Spirit from me.*
PSALM 51:10–11 NLV

Moms the world over are known as the glue that holds families together, because they understand an important truth: one of the most satisfying feelings is being together with someone you love. When we wander from God, we forget how amazing it is to spend time in God's presence. But when we come to our senses, we realize that our spirit longs to come home to Him.

. .

*Lord, I've tried doing my own thing and pleasing
myself. The only thing I've gained is misery. I'm
ready to please You, Father. I just want to be where
You are. Show me how to live for You. Amen.*

BEGIN TO UNDERSTAND

Do not speak evil against one another.... There is only one lawgiver and judge, he who is able to save and to destroy. But who are you to judge your neighbor?
JAMES 4:11–12 ESV

When life is going our way, we can morph into arrogant creatures. Our advice chafes: "If you would just do things my way, life would be better for you." But we must drop the judgment because, in truth, no one's circumstances are identical to ours. Have you considered the other person's secret hardships? Instead of cold platitudes and misguided advice, maybe offer to help and get a firsthand feel for the weight of their load. If you walk in their shoes for a bit, you might find yourself feeling more compassionate about their choices.

Father, I sometimes judge others without understanding what their life is like. Please give me more love and less condemnation. Amen.

BELIEVE EVERY WORD

We always thank God that when you heard the Word
of God from us, you believed it. You did not receive it
as from men, but you received it as the Word of God.
1 THESSALONIANS 2:13 NLV

We can't see gravity, but we know with absolute certainty that it's as real as the dirt we stand on. We recognize through experience, sometimes the painful kind, that what goes up must come down. And though we can't see God with our eyes, we *can* see Him with the eyes of our faith. We know the wonderful things He has done for us. We can count the answers to prayer, feel His comforting arms, and experience His peace. Take Him at His Word today. He is here. He is never leaving. And His love surrounds you.

. .

Father, I know You're here even though I can't
see You. I believe everything You've told me. Amen.

MY LIGHT

Through him all things were made; without him nothing was made that has been made. In him was life, and that life was the light of all mankind. The light shines in the darkness, and the darkness has not overcome it.

JOHN 1:3–5 NIV

Every year on Christmas morning I wake up before the first blush of dawn to sit in the stillness. The kids are sleeping peacefully with the joy of anticipation sweetening their dreams. I snuggle into my favorite chair with my coffee and read about the humble birth of Jesus—the magnificent Savior of a world in need. This year as I looked at the twinkling lights glowing on our tree, I thought about the Light that shines in my darkness— my hope, my life, my rescue and strength. What if every day began as this one?

Father, make every morning a holy contemplation of the light You bring to my world. Amen.

A TRUE DAUGHTER

No discipline seems pleasant at the time,
but painful. Later on, however, it produces
a harvest of righteousness and peace.
HEBREWS 12:11 NIV

We can all probably dredge up a few stories of youthful folly
that end with "...then my parents grounded me for a month."
Although no parent is perfect, we correct our children because
we love them and don't want to see them lead foolish and pain-
filled lives. God disciplines us when we step out of line too.
And the rewards are high—righteousness and peace through
learning to go the right way. And remember the best news—
God's discipline proves our place as His children. "If you are
not disciplined...then you are not legitimate, not true sons and
daughters at all" (Hebrews 12:8 NIV).

Loving Father, thank You for loving me enough
to correct my way. A little pain now will pay
off in righteousness and peace. Amen.

SET FREE

Don't you know that when you offer yourselves to someone as obedient slaves, you are slaves of the one you obey—whether you are slaves to sin, which leads to death, or to obedience, which leads to righteousness? But thanks be to God that, though you used to be slaves to sin, you have come to obey from your heart the pattern of teaching that has now claimed your allegiance. You have been set free from sin and have become slaves to righteousness.

ROMANS 6:16–18 NIV

We all serve something. We spend our days building legacies and fortunes, chasing dreams, and sometimes just running after our own pleasure. Evaluate the ways you spend your time, your money, the things that are important to you. A slave lives to do the bidding of her master. What things are mastering you?

. .

Father, teach me to obey You willingly and joyfully. Amen.

JOY IN THE COMING DAWN

Satisfy us in the morning with your unfailing love,
that we may sing for joy and be glad all our days.
PSALM 90:14 NIV

Dark times sometimes descend over our lives. Many Christians have lived through bleak periods in history, and we're not guaranteed ease and comfort either. But the black night of our current situation gives way to the light of morning when we're enfolded by the steadfast love of God. Because we are players in the greatest love story in history, the rescue of a doomed people, our songs of praise to our great God can still reign in our hearts in spite of desperate circumstances. Our hope cannot be crushed. Our joy cannot be extinguished. Because of Jesus.

* *

Heavenly Father, when I'm passing through dark valleys,
assaulted by difficulties, keep my hope and faith in the
eternal sunrise of dwelling in Your presence. Amen.

MY HOPE AND PORTION

The steadfast love of the LORD never ceases;
his mercies never come to an end; they are new
every morning; great is your faithfulness. "The LORD is
my portion," says my soul, "therefore I will hope in him."
LAMENTATIONS 3:22–24 ESV

We see the new year as a fresh start, but what's significant about a changing date? Why do we feel so empowered to start losing weight or kick a bad habit when the calendar flips? We tell ourselves *next year* will be better. *Next year* I'll change. But what about today? We don't have to wait until the start of a new year to talk to God about our mistakes. And scripture reminds us that there's a ray of hope: His mercy is new every morning. Make Him your portion and hope every day.

* *

Lord, living for You is all I need today and every day. Amen.

THE ULTIMATE GAIN

Whatever things were gain to me, these things I have
counted as loss because of Christ. More than that,
I count all things to be loss in view of the surpassing
value of knowing Christ Jesus my Lord.
PHILIPPIANS 3:7–8 NASB

In Paul's accounting, we have assets and liabilities. But after he met Jesus, what he thought were his assets—his position, power, and obedience to the law—were actually losses. Not only were they worthless, but they were dragging him down. Instead, he discovered that what he thought was a total loss—a crucified Messiah—was the ultimate gain. Do you need to reevaluate where you're finding value? Jesus said, "What will it profit a man if he gains the whole world and forfeits his soul?"

* *

Father, keep me from putting value in worthless
things. Experiencing Jesus' love and friendship
is the unrivaled win. In Jesus' name, amen.

THE RIGHT MOTIVE

"These people honor me with their lips,
but their hearts are far from me."
MATTHEW 15:8 NIV

Do you ever find yourself following God's ways literally but ignoring the deeper meaning behind His commands? I have definitely babysat for a friend or helped my husband clean out the garage—while grumbling to myself the whole time. Jesus was asked once what the greatest commandment was, and He said this: " 'Love the Lord your God with all your heart and with all your soul and with all your mind.' This is the first and greatest commandment. And the second is like it: 'Love your neighbor as yourself' " (Matthew 22:37–39 NIV). Love is the greatest commandment. Our outward actions become meaningless in the absence of love.

Father, please forgive me for doing the right thing outwardly
without love in my heart. Teach me to love like Jesus. Amen.

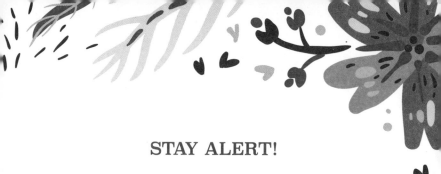

STAY ALERT!

Keep awake! Watch at all times. The devil is working
against you. He is walking around like a hungry lion
with his mouth open. He is looking for someone to eat.
1 PETER 5:8 NLV

Make no mistake, Satan is not your friend. Scripture tells us that in his wake are stolen hopes, death, and destruction. He knows that you've been chosen as God's child, and his biggest pleasure is causing pain or offering you pleasure and position to lure you away from God. Stay alert to your thoughts and motivations, because the enemy is actively working against you. Any time he can cause a Christian to stumble, he hammers another dent in God's reputation. What circumstances have you allowed to plant a seed of doubt about God's love for you?

. .

Father, give me wisdom to be as wise as
a serpent and as gentle as a dove. Amen.

NEVER FORGET

Praise the Lord, O my soul.
And forget none of His acts of kindness.
PSALM 103:2 NLV

Do you need to revitalize a dreary perspective and exchange negativity for a more positive outlook? Following Christ doesn't mean you'll skip through life, happy at every turn. But the glass-half-empty mentality can become a bad habit. Sure, unfortunate things happen, and sometimes nothing seems to be going our way, but a new perspective can keep you from sounding like Chicken Little. Simply remember the kindnesses of God—make a list, write a poem, post them on your mirror, sing about them in the shower. Never forget that you were dead but are now alive!

. .

Father, help me keep things in perspective. Even when
I seem to come out with the short end of the stick
too often, I am abundantly blessed. Amen.

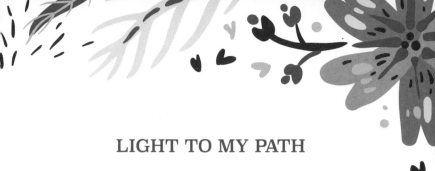

LIGHT TO MY PATH

Your word is a lamp to my feet and a light to my path. I have sworn an oath and confirmed it, to keep your righteous rules.
PSALM 119:105–106 ESV

We navigate our homes with no problem when the lights are on. But when a howling windstorm knocks out the power in the dead of night, our shins take a beating as we grope through the darkness for a flashlight. Are you confused and seeking answers? Don't fall for the enemy's deception that you don't have time to read scripture or it's too difficult to understand. Turn on the light. Pick up your Bible—dust it off if you have to. Your heavenly Father promises you will gain understanding and direction in your choices.

. .

Father, thank You for giving us Your Word.
Give me understanding and discernment
through studying Your ways. Amen.

WHERE'S YOUR TREASURE?

"Do not store up for yourselves treasures on earth,
where moths and vermin destroy, and where thieves
break in and steal. But store up for yourselves treasures
in heaven, where moths and vermin do not destroy,
and where thieves do not break in and steal. For where
your treasure is, there your heart will be also."
MATTHEW 6:19–21 NIV

Many beautiful mansions have fallen into ruins with the passage of time. They may have been the cherished homes of wealthy and influential people in days gone by, but with disuse and disrepair, their expansive floors lose their sheen and once-fashionable paper peels from their walls. Don't hope and trust in fleeting earthly possessions. Where is your treasure? Are you chasing things—cars, clothes, popularity? Or does God hold first place in your life?

Father, teach me to serve others in love. I won't let
passing possessions turn my eyes from You. Amen.

ALWAYS AND FOREVER

"I the LORD do not change."
MALACHI 3:6 NIV

Anne Frank, the brave young girl who hid from the Nazis with her family in an attic, wrote, "[If] you try to improve yourself at the start of each new day…you achieve quite a lot in the course of time. Anyone can do this, it costs nothing and is certainly very helpful." Change can be good. We gain experience and grow, and develop good character. For us, change is unavoidable. But God never changes: He is always God—always good, always there, and always keeps His promises. This is great news for us! We can be sure that He is faithful and won't change His mind about your adoption as His beloved daughter.

. .

Father, it gives me great comfort and courage to know that You are the same yesterday, today, and forever. But continue to shape me into a daughter who pleases You. Amen.

TARRY WITH HIM

Mary Magdalene went and told the followers that she had
seen the Lord. She told them the things He had said to her.

JOHN 20:18 NLV

I come to the garden alone,
While the dew is still on the roses;
And the voice I hear, falling on my ear,
The Son of God discloses.

And He walks with me, and He talks with me,
And He tells me I am His own;
And the joy we share as we tarry there,
None other has ever known.

Do you have a quiet, off-the-beaten-path place or time in your
busy day where you meet with Jesus? If not, ponder the words of
this hymn, "In the Garden," and consider the depth of friendship
you're missing.

. .

Lord Jesus, I want to know more of Your love.
I want to walk with You and talk with You about
the intricacies of life and following You. Amen.

RUNNING FREE

Therefore, since we are surrounded by such a great cloud of witnesses, let us throw off everything that hinders and the sin that so easily entangles. And let us run with perseverance the race marked out for us.
HEBREWS 12:1 NIV

Much to the frustration of gardeners everywhere, dandelions grow right back unless you dig up the root. What sins are crowding out your joy? Beloved, we all mess up, and when we do, God's grace has us covered. But God also desires you to overcome the sins that bring grief to your life and to your Father's heart. Do you stumble often into anger, gossip, jealousy? What root is motivating this behavior? Selfishness? Fear? Pride? Allow God's Word to yank out the deep tendrils of sin strangling your new life in Christ.

. .

Father, lay bare the root cause of my sin. Give me strength through Your Spirit to win victory. Amen.

PEACE IN THE STORM

Jesus was in the stern, sleeping on a cushion. The disciples woke him and said to him, "Teacher, don't you care if we drown?" He got up, rebuked the wind and said to the waves, "Quiet! Be still!" Then the wind died down and it was completely calm. He said to his disciples, "Why are you so afraid? Do you still have no faith?"

MARK 4:38–40 NIV

Do you live your life like you know God is in control? Jesus wasn't sleeping in the boat out of carelessness about His well-being. His peace was anchored in trust. Usually we pray for God to take away whatever hard circumstances we're in, and sometimes He does, but sometimes He allows the storm to rage on and calms His child instead.

Father, whether You calm my storms or fill me with peace while the world falls apart around me, I trust in You. Amen.

CREATION SINGS

The heavens declare the glory of God; the skies proclaim the work of his hands. Day after day they pour forth speech.... Their voice goes out into all the earth, their words to the ends of the world.

PSALM 19:1–4 NIV

It's your birthday, and your favorite triple-chocolate cake awaits! You know that scrumptious confection didn't bake itself any more than the universe created itself. And the note says, "Enjoy!" It's evidence that your husband thought about you, baked your favorite cake, and loves you. In just this way, we can know God is there. The Bible says that God's creation cries out His existence with a clear voice. Stroll through nature today. Find some insects, a budding plant, or a spiderweb. Where do you see God's goodness, love, and power in His creation?

. .

Lord, Your creation shouts Your glory and is irrefutable evidence of Your existence. Amen.

LIVE IN HIS PRESENCE

*[Anna] never left the temple but worshiped night
and day, fasting and praying. Coming up to [Joseph,
Mary, and Jesus] at that very moment, she gave
thanks to God and spoke about the child to all who
were looking forward to the redemption of Jerusalem.*
LUKE 2:37–38 NIV

Anna was a prophetess at the time of Jesus' birth. Scripture
tells us that she was married for seven years and then lived as
a widow until she was eighty-four years old. Even though she
suffered heartbreak as a young woman, she chose to spend her
days in the temple, continually present with her Lord. Anna
was God's chosen vessel to share the news of Jesus' birth with
those at the temple who were waiting for the Messiah. How can
you bring God into every moment of your day and share the
joyous news of Jesus?

Father, may I never leave Your company. Amen.